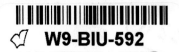

BASEBALL
IN NEW HAVEN

GAMES AT BALL.

The ball is a favorite toy, not only with those for whom our little book is designed, but often with 'children of a larger growth.' The number of different games played with it is very great, but the limits of our book will only allow us to describe some of the most common.

'Base ball' is played by a number, who are divided into two parties, by the leader in each choosing one from among the players alternately. The leaders then toss up

2

One of the earliest written descriptions of the game of baseball can be found in *Boy's Book of Sports*, published in New Haven in 1839. The rules called for laying out four stones as "goals" in a diamond shape, with a "striker" standing at one of the goals. "If the striker miss the ball three times, or he knock it and any of the opposite party catch it, he is out, and another of his party take his place." There were still plenty of differences from the modern game, however. At one point, the text cautions the base runner that "he must be cautious how he ventures too far at a time, for if any of the opposite party hit him with the ball while passing from one goal to another he is out." (Courtesy of the Beinecke Rare Book and Manuscript Library, Yale University.)

BASEBALL IN NEW HAVEN

Sam Rubin

ARCADIA

First printed in 2003.
Reprinted in 2003.

Published by Arcadia Publishing,
an imprint of Tempus Publishing Inc.
2A Cumberland Street
Charleston, SC 29401

Printed in Great Britain.

Library of Congress Catalog Card Number: 2003100292

For all general information, contact Arcadia Publishing:
Telephone 843-853-2070
Fax 843-853-0044
E-mail sales@arcadiapublishing.com

For customer service and orders:
Toll-free 1-888-313-2665

Visit us on the Internet at www.arcadiapublishing.com.

Cover photographs courtesy of the Yale Athletic Department Archives (background); the National Baseball Hall of Fame Library, Cooperstown, New York (front left); and Andy Pippa Photography, the New Haven Ravens (front right, back).

To Mom and Dad.

CONTENTS

ACKNOWLEDGMENTS

This book would not have been possible without a tremendous amount of help from some of the biggest supporters of baseball in New Haven and West Haven. For providing photographs and assistance, thanks go to the Yale Athletic Department, the New Haven Ravens, the Yale University Library, the University of New Haven, Quinnipiac University, Southern Connecticut State University, the National Baseball Hall of Fame Library, the New Haven Colony Historical Society, the Connecticut Historical Society, the National Park Service William Howard Taft National Historic Site, the Memphis-Shelby County Public Library and Information Center, Harry M. Noyes, George Klivak, Bill Dorman, Lori McCarthy, Geoff Zonder, Dan Gooley, Frank Vieira, Rick Leddy, Bob Barton, Joan Finn-Bonci, Bill O'Brien, Bob Dixon, Tony Occhineri, Ron Duke, Jean Kaas, Whitey Piurek, Frances Woodward, Chris Canetti, Art Ceccarelli, Jim Sheehan, Joe Zajac, Adam Schierholz, Corey Brandt, and Joe Yotch.

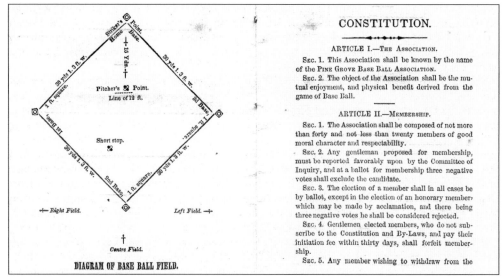

The Constitution, By-Laws, Rules and Regulations of the Pine Grove Base Ball Association of 1859 is one of the earliest signs of organized baseball in the New Haven area. The amateur league's book included a diagram of a field and noted that "the object of the Association shall be the mutual enjoyment, and physical benefit derived from the game of Base Ball." (Courtesy of the New Haven Colony Historical Society.)

INTRODUCTION

Baseball in New Haven has meant many different things over the years. Lately, it has meant summer nights out at historic Yale Field watching future Major League stars with the New Haven Ravens. However, the history of the national pastime in the Elm City goes back far beyond the Ravens' first year, 1994. The first recorded game involving a New Haven team was Yale's 39-13 win over Wesleyan in 1865. Ten years later, New Haven had its first professional team in the National Association, a predecessor of the National League. While that lasted only one year, Minor League Baseball came to New Haven in the late 1880s and lasted into the 1930s. Yale's team also remained a focus of attention, with Yale Field opening in the 1880s and soon attracting crowds as large as 15,000 for games against archrival Harvard. While World War I interrupted baseball in New Haven at both the professional and collegiate levels, that same time period also saw the rise of local product George Weiss. Weiss, who went on to a Hall of Fame career as general manager of the New York Yankees, got his start in New Haven by bringing in stars such as Ty Cobb and Babe Ruth to play his semiprofessional New Haven Colonials. Weiss eventually took over the local Eastern League team and kept baseball interest going with games against Yale. When the new stadium at Yale Field opened in 1928, the first game was a 12-0 victory for the Profs over the Elis.

When Weiss left after the 1928 season, the Great Depression brought a temporary end to professional baseball in New Haven. The game still thrived at the collegiate level, with Yale now led by Boston Red Sox legend Smoky Joe Wood. The Bulldogs brought in Major League teams for exhibition games, including an appearance by Lou Gehrig and the New York Yankees in 1933. That same year, the Yankees also came for a game against the Chevies, a semiprofessional team built around former Bulldog star Albie Booth. The year 1933 also marked the start of the West Haven Twilight League, which produced one of the area's most dominant teams. The Ship's Tavern Sailors soon became so good that they moved on from the Twilight League to play independently, scheduling games against top Negro League teams and even Major League teams. Donovan Field in West Haven was the place to be during the war years of the 1940s, as stars such as Willie Mays and Ted Kluszewski came through to face the Sailors.

The dawn of the television era at the end of the war proved to be too much competition for the Sailors, whose glory years ended in the 1950s. Yale, however, was back in the spotlight around that same time, playing in the first two College World Series with stars such as future president George H.W. Bush. The Bulldogs soon had company at the collegiate level, as New Haven College, Southern Connecticut State College, and Quinnipiac College all began fielding teams. By 1970, it was time for the annual City Series at Yale Field to determine which team was best.

The 1970s also saw the return of Minor League Baseball to the area. The West Haven

Yankees featured future stars such as Ron Guidry and Dave Righetti and won four Eastern League championships. The West Haven Athletics brought the city one more title in 1982 before leaving.

Colleges once again took center stage in the 1980s, as Yale made it back to the College World Series behind Ron Darling, a first-round Major League draft pick. The University of New Haven became a regular at the Division II World Series, and Quinnipiac made its lone series appearance in 1983.

In 1992, Yale's decision to renovate Yale Field wound up bringing about the return of professional baseball to the area; the group behind the renovation applied for, and won, an Eastern League expansion franchise. The Ravens experienced plenty of individual success (Todd Helton, for instance, developed into a Major League All-Star) and also brought the area another Eastern League championship, winning the title in 2000.

One

BEGINNINGS

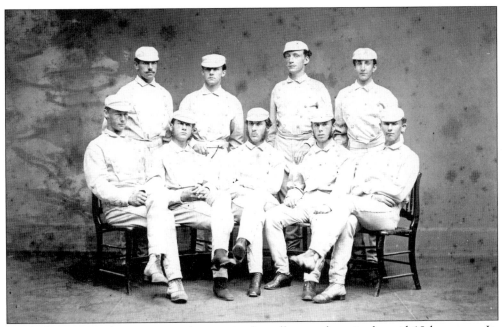

Baseball was a popular extracurricular activity for college students in the mid-19th century. Its popularity increased during the Civil War, when many young men were introduced to it for the first time as soldiers. Yale's first recorded game, a 39-13 win over Wesleyan, came in 1865. The 1869 team was the first to be photographed. That year also marked Yale's first game with Harvard, a 41-24 loss. The "first bounce" rule accounts for the high scores in those days—a batter was out if the ball was caught on the first bounce. Outfielders playing in close to try to get that first bounce allowed frequent home runs. (Courtesy of Pictures of Yale athletics [RU 691], Manuscripts and Archives, Yale University Library.)

An article in the *New Haven Register* on January 8, 1875, advised of efforts to form a professional "base ball" club as part of the National Association. The New Haven team made its debut on April 19, losing to Boston 6-0. A week later, New Haven's professionals and Yale crossed paths for the first time, with the pros beating the Elis 15-5. The pros' remaining games did not go so smoothly. With a 7-40 record, New Haven did not even make it to the end of the season. That was also the final year for the National Association, as it was replaced by the National League the following season. (Courtesy of the New Haven Ravens.)

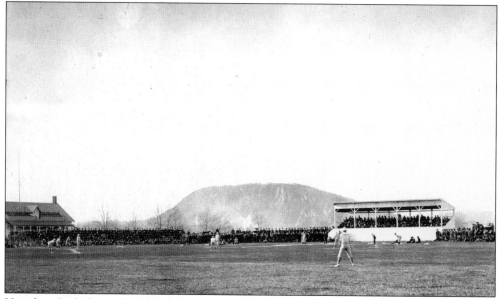

Hamilton Park, located in the shadow of West Rock in the area bounded by Whalley Avenue, Pendleton Street, and the West River, was home to New Haven's National Association team for that one season. It was also used as a racetrack and was the home for the Yale baseball team. The park featured a grandstand with room for 200 people and an admission charge of 50¢. (Courtesy of Pictures of Yale athletics [RU 691], Manuscripts and Archives, Yale University Library.)

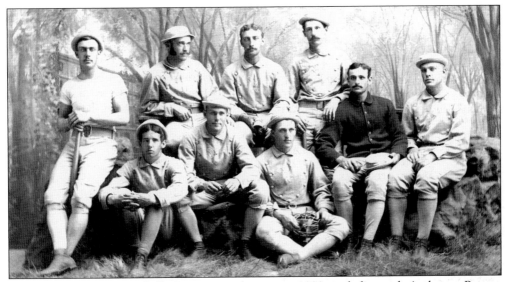

The Intercollegiate Baseball Association began in 1880 and featured Amherst, Brown, Dartmouth, Harvard, Princeton, and Yale. Yale's 1882 team won the Intercollegiate championship in part due to the work of Walter Camp (back row, fourth from left). Camp, known more for his role as the father of American football, was also an outstanding pitcher and one of the first to master the curve ball. When he was not pitching, he played shortstop and left field. (Courtesy of Pictures of Yale athletics [RU 691], Manuscripts and Archives, Yale University Library.)

After graduating, Walter Camp was a key part of Yale's baseball teams as an advisory coach. He also worked as an editor for the Spalding baseball guides and published some baseball books of his own. (Courtesy of Walter Chauncey Camp Papers, Manuscripts and Archives, Yale University Library.)

SPALDING'S ATHLETIC LIBRARY

BASE BALL
BY WALTER CAMP

PUBLISHED BY THE
AMERICAN SPORTS
PUBLISHING CO.
241 BROADWAY
NEW YORK.

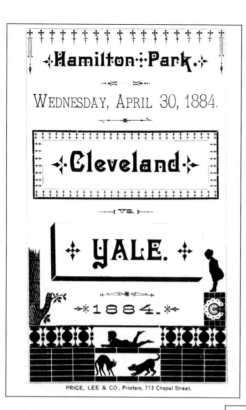

Games against Major League teams were commonplace for Yale in the early years. Yale's 1884 schedule included games with the Philadelphia Athletics and New York Metropolitans of the American Association, and the Boston Beaneaters of the National League. Yale also hosted the National League's Cleveland Blues at Hamilton Park, falling 13-9. (Courtesy of the New Haven Colony Historical Society.)

In the midst of a successful Major League career that would land him in the National Baseball Hall of Fame, James O'Rourke found the time to earn a law degree from Yale in 1887—11 years after he had registered the first hit in the history of the National League. O'Rourke was one of the founders of the Connecticut League, which featured a New Haven team from 1898 through 1912. To show he had not lost a step, O'Rourke put aside his duties as league president and caught a nine-inning game for New Haven on September 14, 1912— 13 days after his 62nd birthday. (Courtesy of the National Baseball Hall of Fame Library, Cooperstown, New York.)

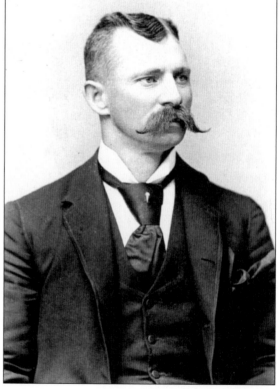

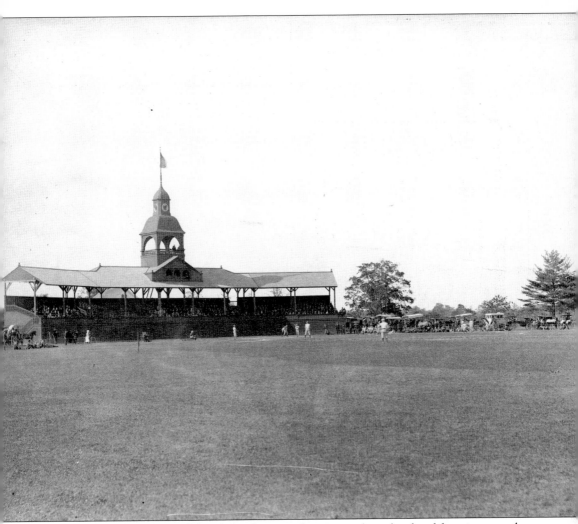

The increasing interest in athletics led Yale to purchase an apple orchard and farm just past the West River in 1882, turning it into fields for various sports. In 1884–1885, William H. Crocker (Class of 1882) donated the first grandstand, and the Yale baseball team was able to move its home games over from Hamilton Park to the new facility, Yale Field. It was considered the height of fashion to hire a horse-drawn carriage with friends for 50¢ and ride out to the game. The outfield was part of Yale's football field. While the football team eventually moved across the street (the Yale Bowl opened in November 1914), the baseball team still plays at the same site. (Courtesy of Pictures of Yale athletics [RU 691], Manuscripts and Archives, Yale University Library.)

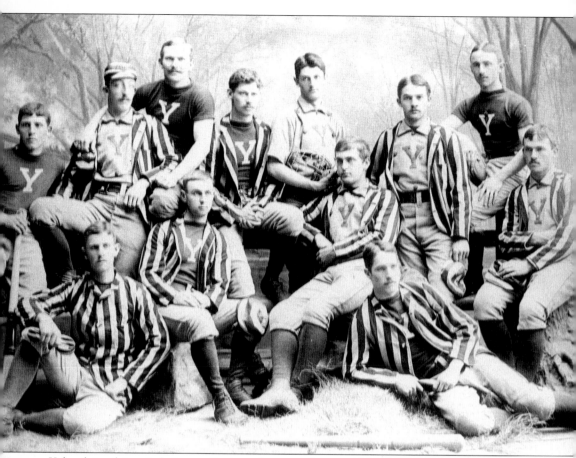

Yale claimed its sixth Intercollegiate championship in 1886, a season highlighted by the school's 200th victory—an 11-1 triumph over Oyster Point. To the left in this photograph is Amos Alonzo Stagg. The man holding the catcher's mask is Jesse Chase Dann. Stagg, who captained the team in 1888, formed a legendary battery with Dann, who captained the team in 1887. Dann was said to have become a catcher only because no one could handle his pitches. Stagg was particularly successful against Harvard, winning 15 of the 21 games he pitched. (Photograph by L. Covello Photos, courtesy of the Yale Athletic Department Archives.)

Stagg pitched Yale to five baseball championships and received six professional contract offers, all of which he turned down. "I never did a wiser thing," he said. "If it is money that the college man wants, he ought to be able to make more on a real job than by peddling a physical skill. If it is fame, let him go after a brand that won't turn green and shiny in the seat before he is 30." (Courtesy of Images of Yale individuals [RU 684], Manuscripts and Archives, Yale University Library.)

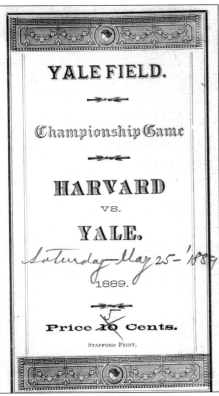

After the Intercollegiate Baseball Association was formed in 1880, Yale won 9 of the first 10 championships but, most importantly, turned the tide in its series with Harvard. After losing its first 8 games with the Cantabs (and 18 of 28 prior to 1880), Yale posted a 14-5 mark against Harvard from 1880 through 1884. Yale beat Harvard 15-3 in this 1889 game on its way to another Intercollegiate title. (Courtesy of the New Haven Colony Historical Society.)

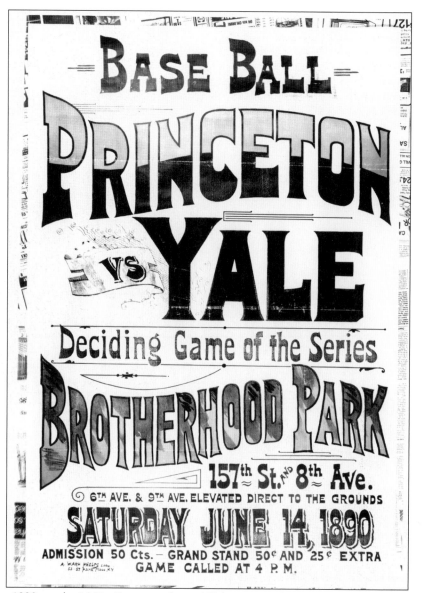

From the 1880s to the 1960s, Princeton hosted Yale as part of commencement day. The teams would play another game the week after commencement if they had split the first two games. In 1890, Princeton won 1-0 at Princeton, and Yale won 3-2 in New Haven. The teams met again in New York before a crowd of 6,000. Amos Alonzo Stagg showed up with rubber bandages on his arm, which was rumored to be sore. He eventually tore those off and, after allowing seven runs in the first three innings, settled down to allow just one more. The Bulldogs had pulled within one entering the eighth when a rainstorm soaked the field. Amidst the protests of the Princetonians, the umpires ordered the game to resume, and Yale scored the tying run in the bottom of the inning. Princeton scored once in the ninth, but the heavens opened up again, ending the game and forcing the score to revert back to where it was at the end of the eighth (8-8). The teams finally settled the affair by playing again on June 18, with Yale winning 6-5. (Courtesy of Pictures of Yale athletics [RU 691], Manuscripts and Archives, Yale University Library.)

Listed at five feet three inches tall, 1893 Yale captain William Murphy earned nicknames like "Top Midget" and "Tot." As a big-leaguer for three seasons with the New York Giants, he was known simply as "Yale" Murphy. He went on to coach at Penn, Stanford, Yale, and Navy before dying of tuberculosis in 1906 at the age of 36. (Courtesy of the Yale Athletic Department Archives.)

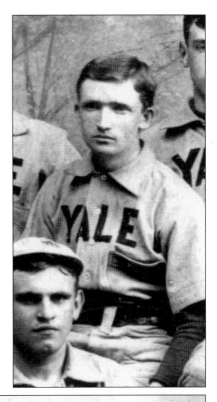

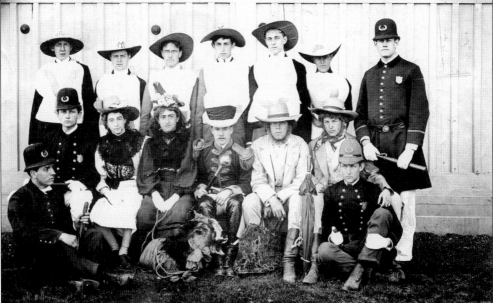

The enthusiasm for baseball at Yale at the end of the 19th century spilled over into the undergraduate ranks in the form of class baseball. The seniors, juniors, sophomores, and freshmen each fielded a team and played against each other for a championship. These games were not taken very seriously, however, as the Class of 1898's attire indicates. (Courtesy of Pictures of Yale athletics [RU 691], Manuscripts and Archives, Yale University Library.)

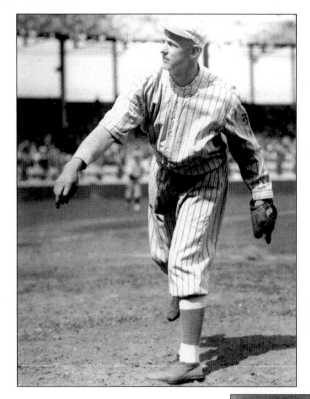

Yale stopped in New York for a game against the Giants on the way back from its spring trip in 1901. The Giants took a 4-1 lead into the ninth inning and inserted a 19-year-old pitcher who had appeared in six games for them the previous season. Yale rallied for four runs against him, making future Hall of Famer Christy Matthewson the losing pitcher. (Courtesy of the National Baseball Hall of Fame Library, Cooperstown, New York.)

Captain Frank McDonnell Camp Robertson (who insisted on using his entire name) drove in the winning run against Matthewson. He was also responsible for one of Yale's greatest pitching performances. On June 3, 1899, he no-hit Princeton 8-0. Two superb fielding plays helped Robertson, including an over-the-shoulder catch in the third inning by shortstop Stuart Camp and a leaping grab in the sixth inning by center fielder A.Y. Wear. (Courtesy of the Yale Athletic Department Archives.)

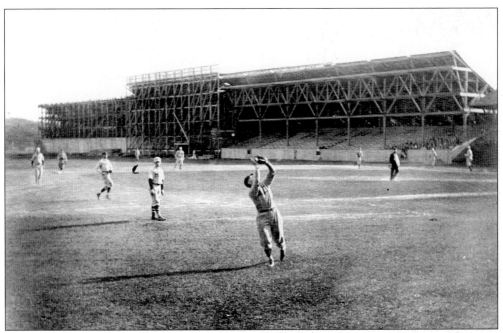

As crowds continued to grow, Yale continued to expand the grandstand at Yale Field, as this 1908 photograph of third baseman Charles Williams during the Holy Cross game shows. (Courtesy of Pictures of Yale athletics [RU 691], Manuscripts and Archives, Yale University Library.)

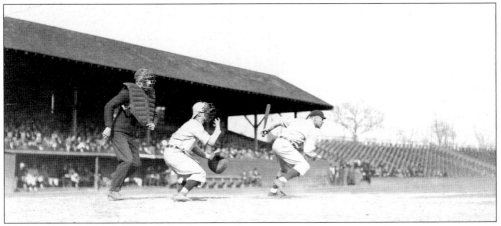

Yale also replaced the original grandstand with a structure that was more Spartan in appearance (no more ornate cupola with a clock towering behind home plate) but that did have one new amenity: dugouts. (Courtesy of Pictures of Yale athletics [RU 691], Manuscripts and Archives, Yale University Library.)

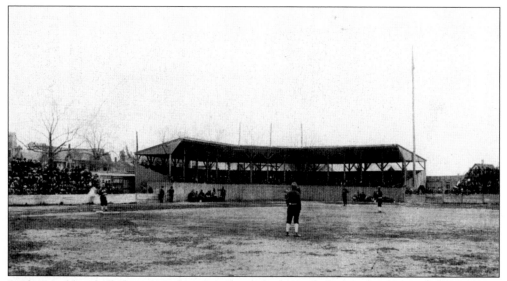

Professional baseball also enjoyed increased popularity at the beginning of the 20th century in New Haven. Fans were first able to watch games at Savin Rock in West Haven in an area bounded by Beach, Summer, Palace, and Grove Streets. The park was moved a few blocks north when George Kelsey began developing the area. In 1902, to accommodate the building of the White City amusement park, the park was moved west to an area bound by Savin Avenue and Oak and Marsh Streets. There, the field known as "the Prairie" was home to New Haven's Connecticut League team. (Courtesy of Bill Dorman.)

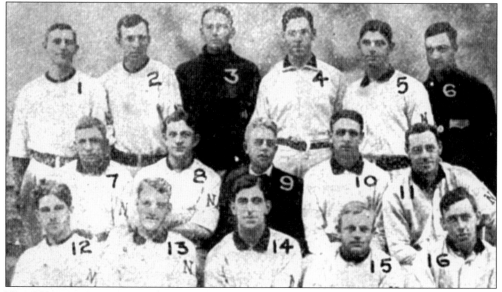

New Haven's 1910 entry in the Connecticut League lost 10 of 12 games at one point midway through the season but rallied for a fourth-place finish at 65-55. The White Wings featured Roger Peckinpaugh (front row, center), who hit .255 in 101 games and posted the second-best fielding percentage among league shortstops. Peckinpaugh made his big-league debut in September of that year and went on to enjoy a 17-year career that included the 1925 American League MVP award. (From *Spalding's Official Base Ball Guide 1911*, courtesy of the Yale University Library.)

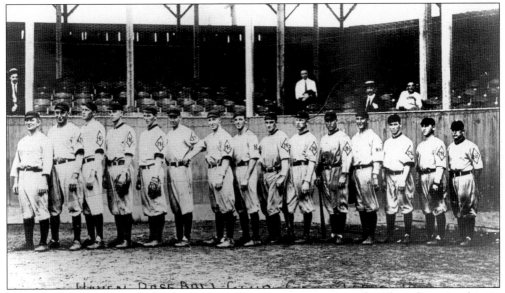

New Haven's long run in the Connecticut League came to an end with a championship in 1912. The White Wings ran away with the title, spending the entire season in first place and finishing 76-46, nine and a half games ahead of Hartford. The next season, the Connecticut League became the Eastern Association. That league lasted only two seasons. After one year in the Federal League, New Haven joined the Eastern League in 1916. (Courtesy of the Connecticut Historical Society, Hartford.)

Jacob "Bugs" Reisigl led the White Wings with 21 wins in 1912. Reisigl had been in the big leagues the previous year, posting a 6.23 ERA in 13 innings with Cleveland. He made it up to the International League with Providence the following year but never got back to the bigs. (Courtesy of the National Baseball Hall of Fame Library, Cooperstown, New York.)

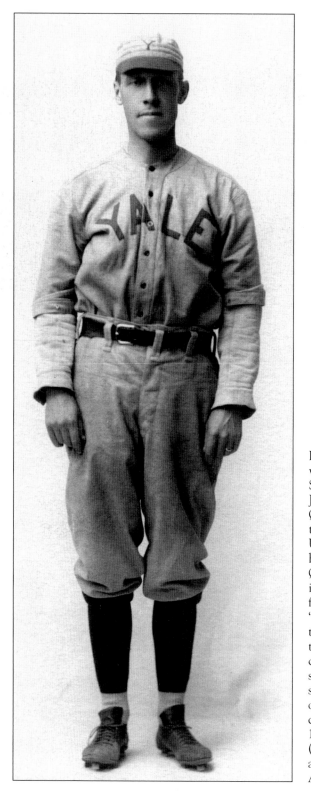

Frank Quinby was a two-year letter winner for Yale, and his brothers Sam (captain of the 1896 squad) and Joe also played. As coach, however, Quinby was caught in the middle of the "coach on the bench" issue. Until 1905, the team did not even have a formal coach, and even after Quinby took over that role in 1912, it remained undefined. Many still felt that, as one observer put it, "championship games should be trials of strength between the two teams and not between the two coaches." Thus, coaches sat in the stands during games, and captains still maintained much of the control over the team. Under fire from his captains, Quinby resigned in July 1915 with an 82-41-3 record. (Courtesy of Pictures of Yale athletics [RU 691], Manuscripts and Archives, Yale University Library.)

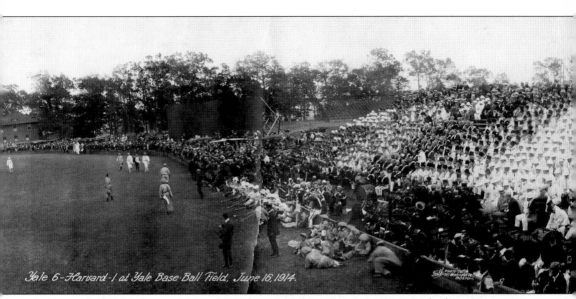

Yale 6 - Harvard - 1 at Yale Base-Ball Field, June 16, 1914.

By the early 1900s, the crowds at the Yale-Harvard commencement game had grown to epic proportions. With bleachers now lining the outfield, a crowd estimated at 15,000 packed Yale Field on June 16, 1914. Graduates began arriving an hour and a half before the first pitch and paraded around the field prior to the game. Fans of the current stadium will note the early version of the "Green Monster" batter's eye in center field. (Photograph by the Falk Photo Company, courtesy of Pictures of Yale athletics [RU 691], Manuscripts and Archives, Yale University Library.)

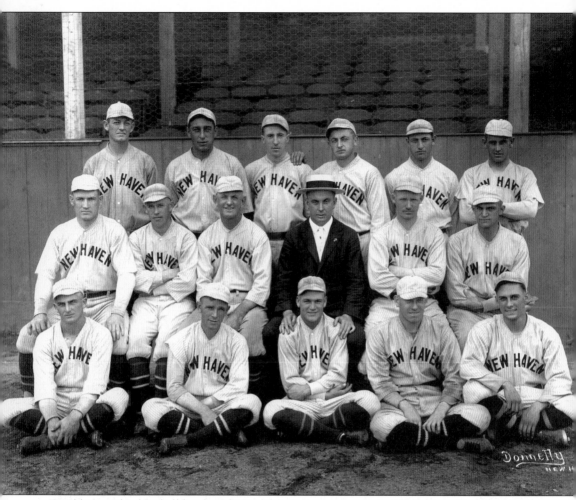

World War I hit baseball hard, and New Haven was no exception. Yale played just four games in 1917 before ending its season. New Haven's professional team won the Eastern League title in 1917, going 66-35. Future big-leaguers Frank Woodward (front row, left) and Jim "High Pockets" Weaver (front row, right) each won 14 games. The real accomplishment was just finishing the year. With the war raging and with increased competition from motion pictures, dozens of minor leagues across the United States had already folded. The trend finally caught up to the Eastern League the following year. Play was suspended on July 22, 1918, leaving New Haven's baseball future in doubt. Fortunately for local fans, a local boy with big-league aspirations was prepared to make a move that would put the city back on the baseball map. (Photograph by Donnelly, courtesy of Frances Woodward.)

Two

THE RISE OF
GEORGE WEISS

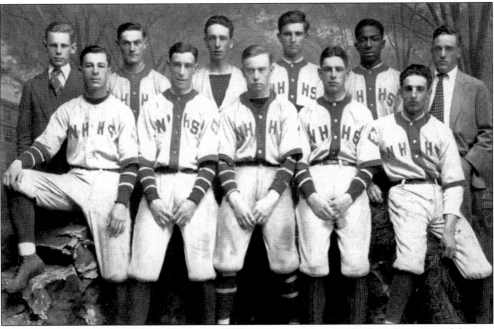

New Haven High School (now known as Hillhouse) proved to be the breeding ground for one of New Haven's most successful teams. George Weiss, who went on to a Hall of Fame career as New York Yankees general manager, got his start as the high school team's business manager. Weiss moved on to Yale but also formed a semiprofessional club with former New Haven High School players. The school produced such stars as future Yankee Joe Dugan, shown here (front row, second from left) as captain of the 1916 team. Weiss added college stars he came to know through Yale. His "New Haven Colonials" were soon the talk of the town. (Courtesy of the New Haven Colony Historical Society.)

One of the Colonials' early stars was New Haven High School's Emmons "Chick" Bowen. While Weiss remained in New Haven, Bowen moved on to Holy Cross and eventually to the New York Giants, playing three games in 1919. In 1922, he returned to his alma mater as baseball coach and mentored future big-leaguers such as Eddie Wilson and Jimmy Sheehan. After his untimely passing in 1948, the high school's baseball field was named after him. (From the Emmons Bowen Babe Ruth League 1972 program, courtesy of Joan Finn-Bonci.)

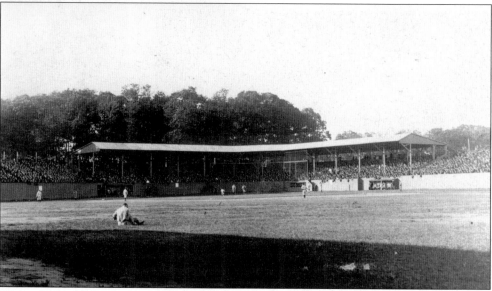

Weiss obtained a lease for the Colonials at Lighthouse Point Park, just outside of New Haven and therefore not regulated by the blue laws that prohibited games on Sundays. Not satisfied with just being the only game in town each Sunday, he also lined up every variety of interesting opponents, ranging from a Chinese University team to a Bloomer Girls team. He even began lining up Major League opponents, including a game against the Yankees at the Polo Grounds. Here, the Colonials take on Brooklyn. (Photograph by Leavitt, courtesy of the National Baseball Hall of Fame Library, Cooperstown, New York.)

One of Weiss's biggest coups was attracting Ty Cobb (left, with New Haven's Danny Murphy) to play for him. Cobb at first insisted on a $350 guarantee to make the trip to New Haven. When Weiss paid him $800, Cobb was impressed. He wound up coming back often while his Detroit Tiger teammates were idle in either Boston or New York. (Courtesy of the National Baseball Hall of Fame Library, Cooperstown, New York.)

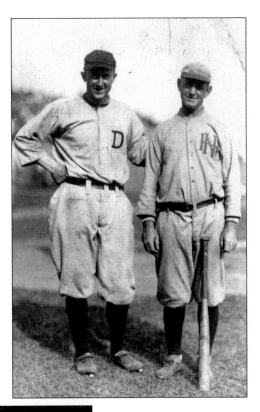

Just days after the 1916 World Series, Weiss managed to get the world champion Red Sox to play against the Colonials at Lighthouse Point. With Babe Ruth pitching for Boston, Weiss inserted a ringer (Ty Cobb at first base) into his lineup, and the Colonials managed to tie the Sox 3-3. Following the game, American League president Ban Johnson fined the Boston players and denied them the use of their World Series emblems for violating the rule that all teams must disband after the World Series. (Courtesy of the National Baseball Hall of Fame Library, Cooperstown, New York.)

27

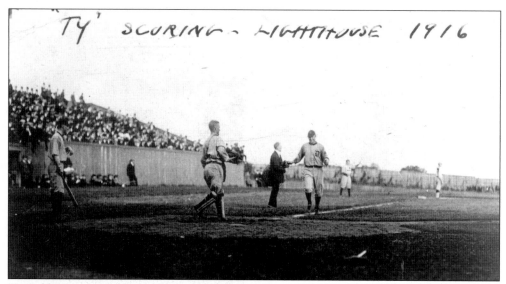

"TY" SCORING – LIGHTHOUSE 1916

Ty Cobb went 2-4 for New Haven in the game against Babe Ruth and the Red Sox, scoring a run during the Colonials' three-run fourth. Cobb also pulled off the hidden-ball trick while playing first base. After Red Sox outfielder Olaf Hendricksen singled, Cobb went to the mound ostensibly to calm down pitcher Peter Falsey. When he returned to first base, Hendricksen assumed Cobb had left the ball with Falsey and took his lead. Cobb then took the ball out from under his arm and tagged Hendricksen out to the delight of the crowd. (Courtesy of the National Baseball Hall of Fame Library, Cooperstown, New York.)

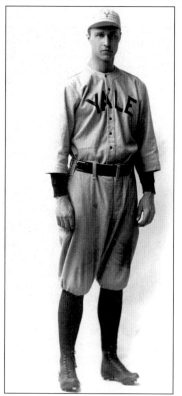

Weiss also scheduled games for the Colonials against Yale. With big-leaguer Chief Bender on the mound for New Haven, the Elis pounded out a 10-2 win on March 31, 1917. One of the hitting stars was first baseman Prescott Bush, who got two doubles off the future Hall of Famer. Bush went on to some noteworthy accomplishments as a senator from Connecticut and as the father of future president George H.W. Bush. (Courtesy of Pictures of Yale athletics [RU 691], Manuscripts and Archives, Yale University Library.)

By 1919, the Eastern League had had enough of competing with George Weiss and sold him the New Haven club. Weiss (left) went about fixing up the Savin Rock stadium and convinced former big-leaguer Chief Meyers (right) to come on board as player-manager. The season did not work out as planned; Meyers gave up his managerial duties at the end of June with the club just 14-26. Danny Murphy, who had managed the club before Weiss's arrival, returned to manage the remainder of the year, and the team finished next-to-last. (Courtesy of the New Haven Colony Historical Society.)

THE CRITERION

NEW HAVEN

MAY 14, 1919

5 CENTS THE COPY

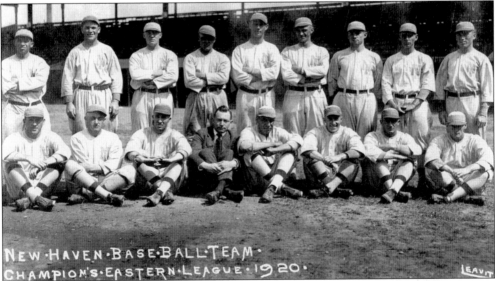

NEW·HAVEN·BASE·BALL·TEAM·
CHAMPIONS·EASTERN·LEAGUE·1920·

LEAVITT

Weiss (front row, fourth from left) moved his team into a new stadium in 1920, Weiss Park in Hamden, and signed Hall of Famer Chief Bender (front row, fifth from left) as his new manager. With Bender at the helm (and, more importantly, on the mound), New Haven went 79-61 and won the Eastern League. Bender posted 25 wins and 252 strikeouts. The team also featured future big-leaguer Frank "Beauty" McGowan (front row, far right). The 18-year-old hit .270 and debuted in the major leagues two years later. (Photograph by Leavitt, courtesy of Frances Woodward.)

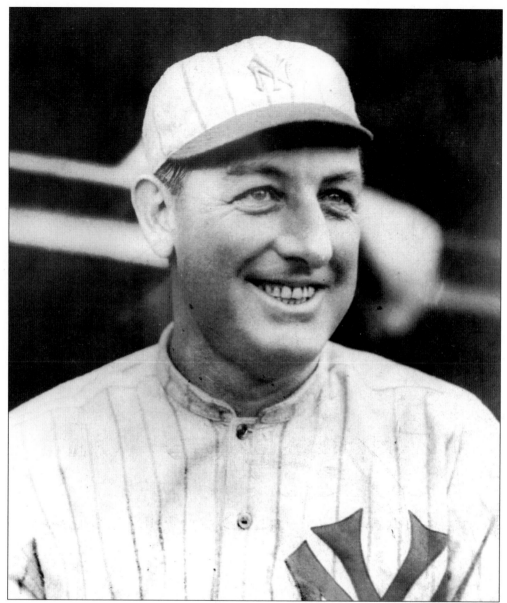

For 1922, Weiss brought on board another former big-leaguer as manager—Wild Bill Donovan. The team went 100-51, winning another pennant and beating the International League champion Baltimore Orioles 2-1 prior to the Junior World Series. A year later, tragedy struck. On the way to the winter meetings in December, the train Weiss and Donovan were on experienced engine trouble. The second section of the train went ahead, leaving behind the first section (with Weiss and Donovan) and the third section. Near Forsyth, New York, the second section ran through a car stalled on the grade crossing without stopping. The first section, some 15 minutes behind, saw the car on fire by the side of the tracks and came to a stop. The third section, now right behind the first section, could not see that it had stopped until it was too late. It plowed into the sleeping car at the back, killing Donovan and injuring Weiss. The next spring, the team unveiled a memorial tablet in Donovan's honor at Weiss Park. (Courtesy of the National Baseball Hall of Fame Library, Cooperstown, New York.)

On option from the Pittsburgh
Pirates, future Hall of Famer Joe
Cronin hit .320 in 66 games for
New Haven in 1926. Two years
later, he was in the major leagues
for good. The Pirates sold him to
the Red Sox after the 1934 season,
and Cronin wound up returning to
New Haven as player-manager
when Boston faced Yale in an
exhibition game at Yale Field in
1939. (Courtesy of the National
Baseball Hall of Fame Library,
Cooperstown, New York.)

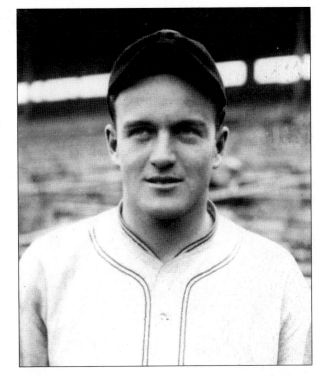

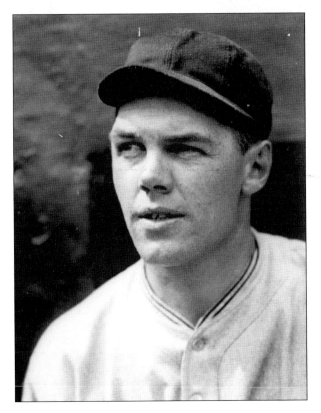

Former New Haven star Johnny
Moore made his big-league debut
in 1928 with the Chicago Cubs,
going hitless in four at-bats. He
was in the big leagues for eight of
the next nine seasons, including
one game in 1936 in which he hit
three straight home runs for the
Philadelphia Phillies. The next
season was his last until 1945,
when he returned to the majors at
the age of 43 for seven games.
(Courtesy of the National Baseball
Hall of Fame Library,
Cooperstown, New York.)

31

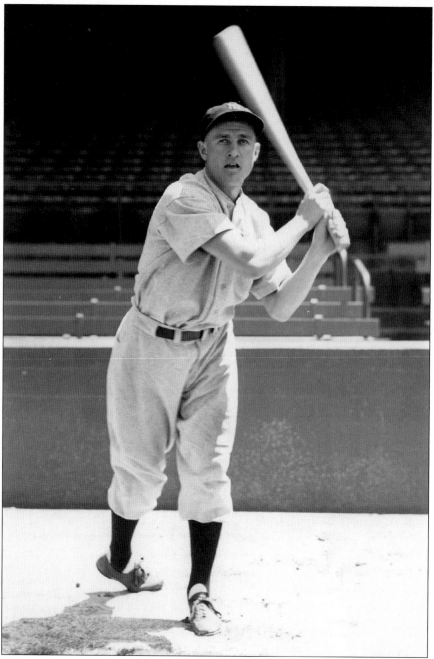

One of George Weiss's best finds was outfielder Jake Powell, a New Haven Prof who went on to spend parts of 11 seasons in the majors. The New York Yankees acquired Powell from Washington in 1936, inserting him into center field and moving young Joe DiMaggio from left field to right field. Powell slumped and was replaced by Myril Hoag. However, when Hoag was injured after crashing into DiMaggio while chasing a fly, Powell returned to the lineup—in right field. DiMaggio moved over to center field, and the Yankees went on to the World Series. Powell hit .455 in the Fall Classic as the Yankees beat the New York Giants 4-2. (Courtesy of the National Baseball Hall of Fame Library, Cooperstown, New York.)

Early in 1928, Weiss sold his stadium grounds in Hamden to a developer and had the grandstand moved to Savin Rock in West Haven, where New Haven's Eastern League teams had played until 1920. Weiss shifted home plate to the opposite end of where it had been, since Savin Avenue frequently flooded. Those floods now occurred in the outfield; the outside of the right-field fence can be seen in this photograph. The year 1928 also wound up being Weiss's last season in New Haven. In 1929, he took over the Baltimore Orioles of the International League, one step below the big leagues. Three years later, he moved up to the New York Yankees as farm director and eventually became the team's general manager and vice president. He remained with New York through the 1960 season, winning seven World Series titles. (Courtesy of Bill Dorman.)

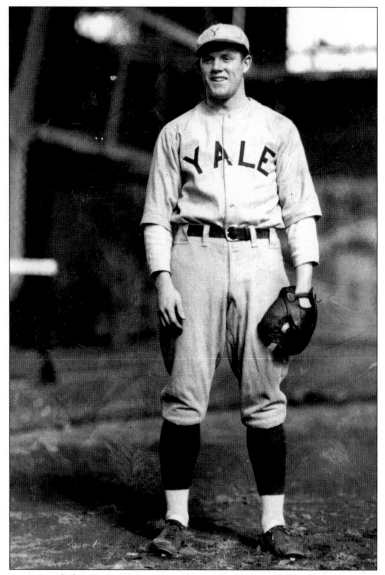

With Weiss gone and the Great Depression looming, Bruce Caldwell was one of those who fought to save professional baseball in New Haven. A two-year letterman at Yale, "Bruising Bruce" played 18 games with the Cleveland Indians in 1928 before he brought his powerful bat to the New Haven Profs. Caldwell hit .367 with 41 home runs in 1929—although not all of his blasts were welcome. His shots over the left-field wall at Savin Rock broke so many windows and caused so many complaints from neighbors that manager Gene Martin threatened to take 15¢ per pane of glass out of Caldwell's salary. Two years later, Caldwell and Martin teamed with boxing referee and promoter David Fitzgerald to try to revive baseball in New Haven. They formed a corporation to run the Eastern League team, giving it the Yale-inspired name "Bulldogs." They renamed the park Donovan Field in honor of Wild Bill Donovan. Still, professional baseball lasted only two more seasons in New Haven, and it was 40 years before it returned. In the meanwhile, much of the baseball attention in the area was focused on Yale and a major project its athletic department had undertaken. (Courtesy of the Yale Athletic Department Archives.)

Three

YALE AND ITS
NEW STADIUM

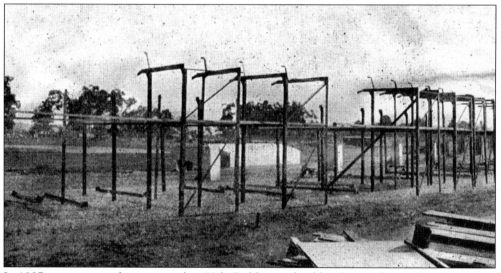

In 1927, construction began to replace Yale Field's wooden bleachers with a steel-and-concrete structure. Architect Charles Duke invoked the arcaded look of Yankee Stadium in designing the new facility. With a roof covering all of the seats and with distinctive arches lining the upper concourse, the grandstand opened on April 12, 1928, with the New Haven Profs taking a 12-0 victory over the Elis. (Courtesy of Architectural documentation for Yale University building and grounds [RU 2], Manuscripts and Archives, Yale University Library.)

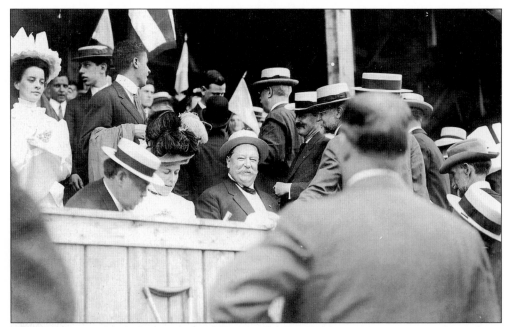

After serving as the 27th president of the United States from 1909 to 1913, Yale graduate William Howard Taft returned to his alma mater as a professor and was a regular at Eli baseball games. A special seat twice as wide as the other seats was built for the 300-pound Taft just behind home plate at Yale Field. Although Taft passed away in 1930, the seat remained in place until the stadium was renovated in 1994. (Courtesy of the National Park Service, William Howard Taft National Historic Site.)

Yale continued developing its baseball program behind a famous big-leaguer. In 1923, Red Sox legend Smoky Joe Wood came on board as freshman coach at the recommendation of former teammate Tris Speaker. After posting a 13-1-1 mark with the freshmen, Wood took over the varsity team in 1924 and went on to lead the Elis for 20 seasons. He compiled a 285-229-2 record, including eight Big Three championships (Yale, Harvard, Princeton) and two Eastern Intercollegiate Baseball League championships (1932 and 1937). (Courtesy of the Yale Athletic Department Archives.)

Francis "Fay" Vincent earned acclaim during his playing days by being named captain of both the football team and baseball team during his senior year of 1930–1931. He also established a school record with six triples in 1929. His son Fay, a 1963 Yale law school graduate, would make a name in baseball in his own right. In 1989, he was named Major League commissioner. (From the 1931 *Yale Banner & Pot Pourri*, courtesy of the Yale Athletic Department Archives.)

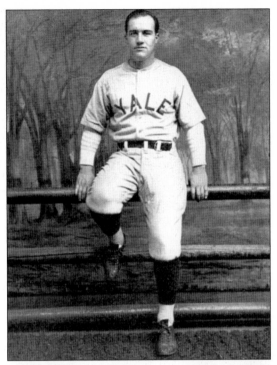

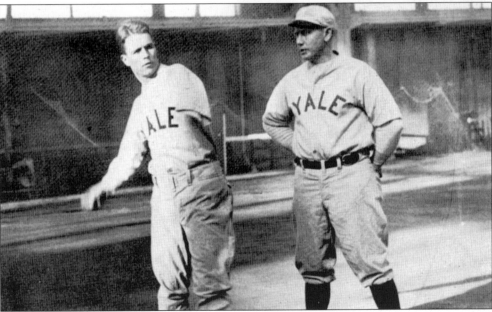

Yale's 1932 season appeared doomed well before it started, as captain-elect Edgar Warren (left) was knocked off a speedboat and struck by a propeller at New York's Raquette Lake in August 1931. Warren's left arm had to be amputated due to an infection. Nevertheless, the team chose to keep him as captain, and Warren made a remarkable comeback. He rejoined the team on May 3, singling and scoring two runs in Yale's 15-2 win over Wesleyan. The Elis went on to finish the season 17-11. (From the 1932 *Yale Banner & Pot Pourri*, Manuscripts and Archives, Yale University Library.)

Standing five feet seven inches, Albie Booth earned the nickname "Little Boy Blue" mainly for his work on the football field, where he led Yale to a 15-5-5 record. However, his last glorious moment came on the baseball field. Stricken by pleurisy his senior season (1932), Booth was told by doctors in April that his Yale career was over. Less than a month later, he was back. In front of 7,500 fans at Yale Field for the Harvard game, Booth hit a grand-slam home run that gave Yale a 4-2 victory. (From the 1929 *Yale Banner & Pot Pourri*, courtesy of the Yale Athletic Department Archives.)

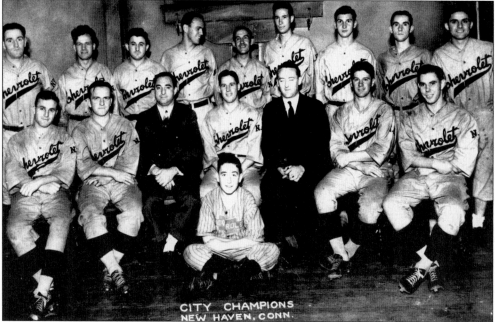

Looking to fill the void left by the departure of New Haven's Eastern League team, local car dealer Jack Cooley put together a semiprofessional team called the Chevrolets to play at Donovan Field. The team, built around Albie Booth (front row, fourth from left), featured former Eastern Leaguers, such as Francis "Huck" Finn (back row, left). The Chevies' run in New Haven was highlighted by a game against the New York Yankees in 1933. (Courtesy of Joan Finn-Bonci.)

A crowd estimated at 8,000 showed up to see Booth (center) and the Chevrolet team take on Babe Ruth (left) and Lou Gehrig's Yankees. Ruth, intent on homering to please the locals, stayed in the game for all nine innings but did not go deep. Gehrig did, and the Yankees won 13-5. The game was a high point for the Chevies, as they lasted just one more year before being moved out of Donovan Field in favor of auto racing. (Photograph by the New Haven Register, courtesy of the Yale University Library.)

A Study In Contrasts

THREE PACKAGES OF DYNAMITE of assorted sizes. George Herman Ruth (on the left if he needs identification) and "Columbia Lou "Gehrig (on the right) tower over New Haven's own mighty mite, Albie Booth but Albie showed an utter disrespect for size and reputation when he led the Chevies against the World's champs at Donovan Field Monday.
 Albie got a double and two singles, the Babe got a single and struck out in four trips. Gehrig got a homer and two singles.

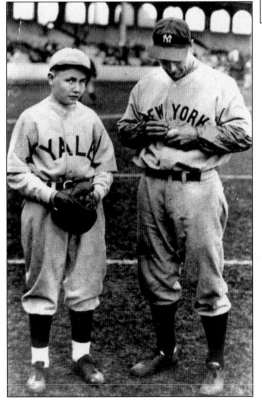

The Yankees also took on Yale at Yale Field in 1933. While Babe Ruth stayed home with a bad cold, Lou Gehrig made the trip. The Iron Horse had to break the ice with young Bob Wood, the son of Yale coach Smoky Joe Wood, who was serving as a Yale batboy that day. "What's the matter, Yale batboys don't talk?" Gehrig asked the awestruck youth before signing an autograph for him. (Courtesy of the Yale Athletic Department Archives.)

39

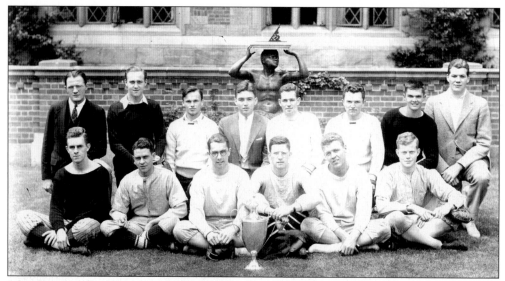

John Broaca was the ace of the Bulldog staff in 1932, but his refusal to pitch against the Chevrolet team in a game Yale lost 8-0 led to him being dropped from the team in 1933. Within a month, he had signed on with the New York Yankees and, by 1934, was in the major leagues. While no longer part of the Yale team, he did pose (back row, left) with the team from his residential college at Yale—Jonathan Edwards—which won the 1934 Intercollege baseball championship. (Courtesy of Pictures of Yale athletics [RU 691], Manuscripts and Archives, Yale University Library.)

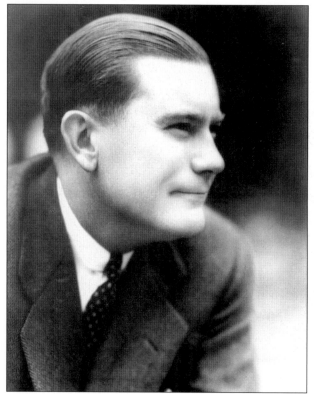

In addition to George Weiss, Yale produced another famous baseball executive in Thomas Yawkey, who graduated cum laude in 1925. Yawkey had grown up around baseball. His uncle William, who owned the Detroit Tigers, raised him after Yawkey's father died when Yawkey was nine months old. When William Yawkey was killed in a car accident, 16-year-old Thomas Yawkey inherited his considerable fortune in timberland, mines, and oil wells. Eight years after graduating from Yale, Yawkey used the money to purchase the Boston Red Sox, a team he owned until his death in 1976. (Courtesy of the National Baseball Hall of Fame Library, Cooperstown, New York.)

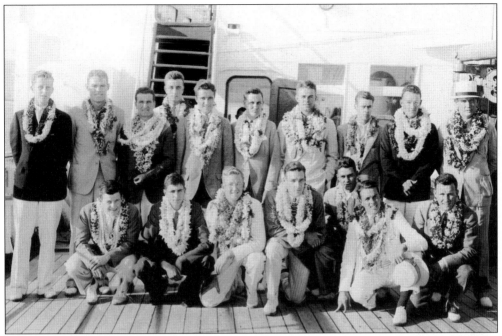

In the summer of 1935, Yale made one of the most extensive trips a U.S. team had made to that point, heading to Japan by way of Hawaii. The Bulldogs are shown here boarding the *Asama Maru* in Honolulu. Yale had tuned up for its Japanese trip by playing eight games in Hawaii, mostly against military teams. (Courtesy of the Yale Athletic Department Archives.)

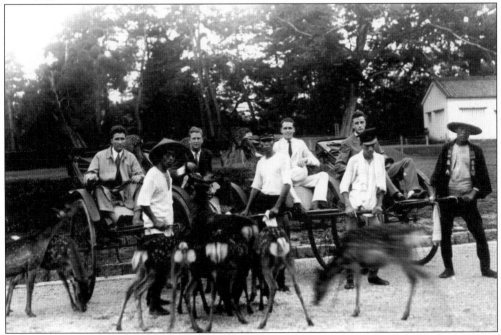

Yale arrived in Yokohama in August and practiced in Tokyo before playing 11 games against six different teams in Japan's Intercollegiate League, posting a 4-6-1 mark. (Courtesy of the Yale Athletic Department Archives.)

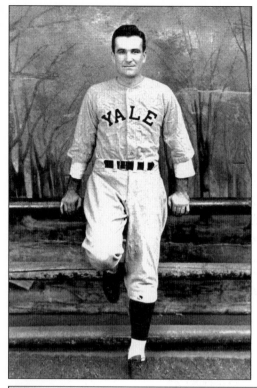

Yale's trip to Japan may have come at a heavy price. A few months after returning from the trip, captain Tom Curtin contracted leucopoenia, a rare blood disease characterized by a decreased number of white blood cells. After an 11-week illness and 21 blood transfusions, Curtin passed away on May 2, 1936. Doctors speculated he may have been exposed to the disease while traveling. (From the 1936 *Yale Banner & Pot Pourri*, courtesy of the Yale Athletic Department Archives.)

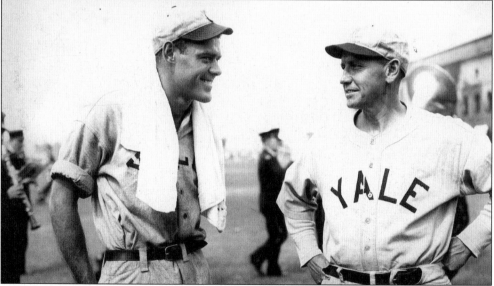

Larry Kelley (left), winner of the Heisman Trophy for his exploits on the gridiron, also starred for Smoky Joe Wood's baseball team. As captain of the 1937 team, Kelley helped Yale win the Eastern Intercollegiate Baseball League with a homer, double, and single in a 9-2 win over Princeton and a single, double, and triple in his final game, a 13-3 win over Harvard. After graduation, he turned down a reported $5,000 contract with the St. Louis Cardinals, choosing instead to go into teaching and coaching at the preparatory school he had attended before coming to Yale. (Courtesy of the Yale Athletic Department Archives.)

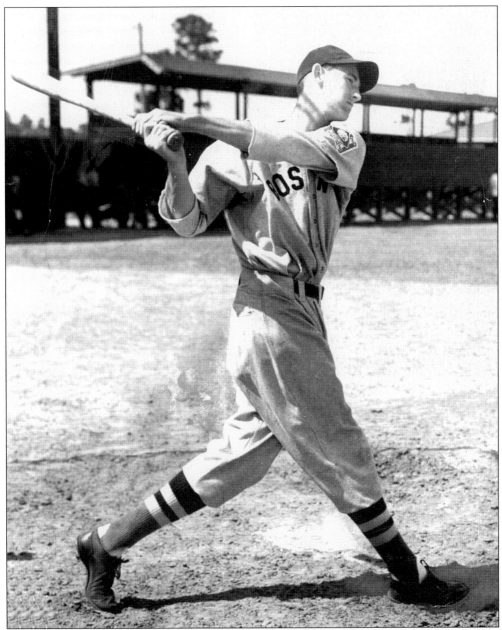

Two days before making his Major League debut in 1939, Ted Williams was at Yale Field with Jimmie Foxx and the rest of his Red Sox teammates for an exhibition game with Yale. Williams was already enough of a phenom that the crowd took great delight in watching him strike out three times, including once with the bases loaded in the first inning against Eli hurler Al Stevens. Williams was also robbed of a home run by Joe Wood Jr. and finished the game 0-4. He did draw a walk and score a run as the Red Sox eked out a 6-5 win over the Elis. (Courtesy of the National Baseball Hall of Fame Library, Cooperstown, New York.)

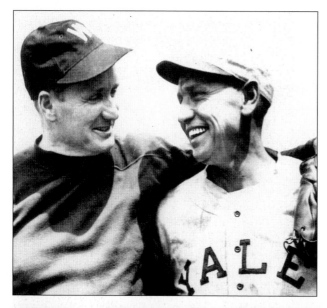

Smoky Joe Wood (right) got together with Walter Johnson (left) at Fenway Park for an old-timers game in 1939. The two had been inexorably linked ever since Wood had outdueled Johnson 1-0 in 1912 on his way to tying the Big Train's record of 16 consecutive wins. "Can I throw harder than Joe Wood?" Johnson once said. "Listen, my friend, there's no man alive can throw harder than Smoky Joe Wood." (Courtesy of the Yale Athletic Department Archives.)

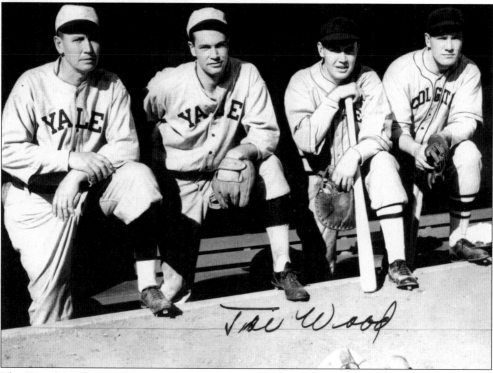

The Wood family was the story when Yale took on Colgate at Yale Field in 1941. Yale coach Smoky Joe Wood (left) sent his son Joe (second from left) to the mound for the Elis. Colgate started Steve Wood (right) on the mound and Bob Wood (second from right) at first base. Young Joe Wood, the Yale captain, picked up the win and went 3-5 as Yale prevailed 11-5. The two teams played again the following season, with Colgate prevailing 6-5 in 10 innings. That would be Smoky Joe's last season as Yale head coach. (Courtesy of the Yale Athletic Department Archives.)

Plagued by colitis for the last year of his Major League career (a condition that also kept him out of military service), Yankee legend Red Rolfe retired in 1942 and came to Yale as a basketball and baseball coach. He enjoyed a successful run on both the diamond (51-25-3) and the hardwood (48-28) before returning to the Yankees as a coach in 1946. (Courtesy of the Yale Athletic Department Archives.)

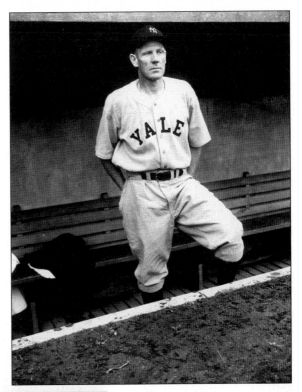

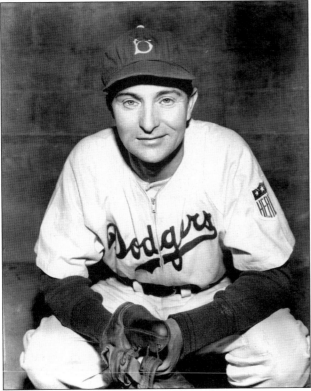

The war years saw a number of Major League teams pass through New Haven, starting with the Brooklyn Dodgers in 1943. Future Hall of Famer Paul Waner led the Bums into Yale Field on April 8 and broke a scoreless tie with an RBI single in the ninth. Brooklyn wound up with a 2-1 win in front of a crowd of 5,000. (Courtesy of the National Baseball Hall of Fame Library, Cooperstown, New York.)

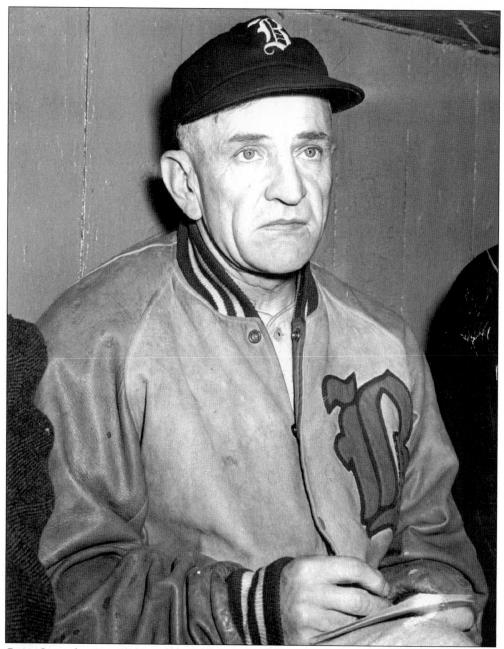

Casey Stengel managed the Boston Braves to an 18-0 win over Yale at Yale Field in 1943, but it was his last year at the helm of that team. Another connection from New Haven got him back in the big leagues six years later. George Weiss, who had befriended Stengel when both were in the Eastern League in 1925, hired him as New York Yankees manager in 1949. The pair went on to win seven World Series together. Stengel never forgot the lessons he learned from being around New Haven, however. When managing the New York Mets near the end of his career, he summoned former Bulldog Ken MacKenzie from the bullpen and gave him just one piece of advice for dealing with the opposing batters: "Make like they're the Harvards." (Courtesy of the National Baseball Hall of Fame Library, Cooperstown, New York.)

46

Four

THE SAILORS ARRIVE

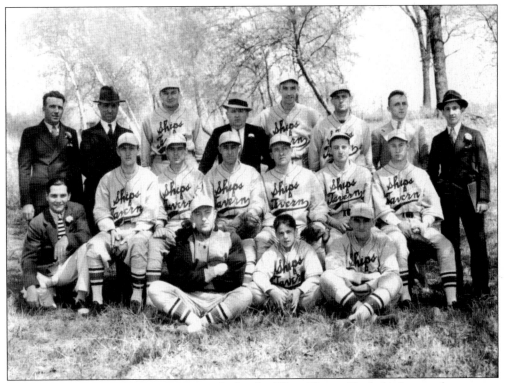

An amateur league playing at Painter Park, the West Haven Twilight League began as a diversion from the Great Depression in 1933. It wound up producing one of the area's most legendary teams. Local restaurateur Maurice Quigley (back row, fourth from left) turned his Ship's Tavern team into a powerhouse, winning the league pennant four times and also winning 30 consecutive games. It soon became clear that the team had outgrown the amateur rank, and the cry went out to "Break up the Sailors." (Courtesy of Harry M. Noyes.)

The Sailors' star pitcher was a left-hander named Harry Noyes. Noyes, whose father had played professional ball in the Eastern League, helped put the Sailors on the map with a 4-0 win over an excellent Center Shoe team in the 1935 Twilight League opener before an estimated 7,000 fans. However, with the team eager for the best possible competition, Noyes made a bold move—he quit pitching and became a partner with Quigley. With Quigley as president and Noyes as manager, the Sailors moved from Painter Park to Donovan Field and joined the Connecticut State Baseball League as the West Haven Sailors. They won the league title in their first season, 1939. (Courtesy of Harry M. Noyes.)

Games between Yale and the local professional and semiprofessional teams were commonplace in the early 1900s, and the West Haven Sailors initiated their own "town-gown" series with the Elis in 1941. Yale's Dick Ames and West Haven's Amby Reynolds were locked in a scoreless pitchers' duel through five innings, but the Sailors reeled off seven runs in the final four innings. Yale scored five in the bottom of the ninth but still came up short, 7-5. (Courtesy of Harry M. Noyes.)

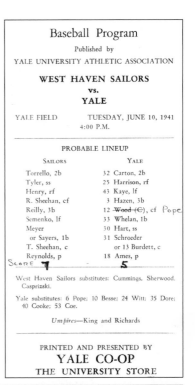

Baseball Program

Published by

YALE UNIVERSITY ATHLETIC ASSOCIATION

WEST HAVEN SAILORS
vs.
YALE

YALE FIELD TUESDAY, JUNE 10, 1941
4:00 P.M.

PROBABLE LINEUP

SAILORS	YALE
Torrello, 2b	32 Carton, 2b
Tyler, ss	25 Harrison, rf
Henry, rf	43 Kaye, lf
R. Sheehan, cf	3 Hazen, 3b
Reilly, 3b	12 Wood (C), cf Pope
Semenko, lf	33 Whelan, 1b
Meyer	30 Hart, ss
or Sayers, 1b	31 Schroeder
T. Sheehan, c	or 13 Burdett, c
Reynolds, p	18 Ames, p

Score 7 - 5

West Haven Sailors substitutes: Cummings, Sherwood, Casprizski.

Yale substitutes: 6 Pope; 10 Besse; 24 Witt; 35 Dore; 40 Cooke; 53 Coe.

Umpires—King and Richards

PRINTED AND PRESENTED BY
YALE CO-OP
THE UNIVERSITY STORE

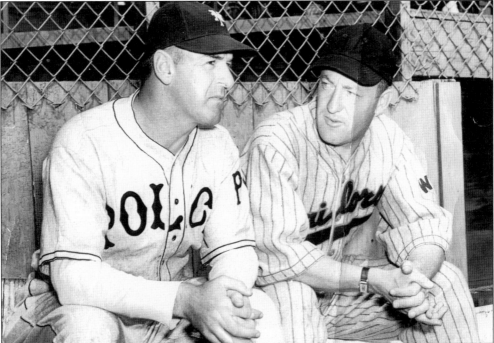

One of the Sailors' biggest rivals was the New York Police Department team. Police manager Roy Auer (left) is shown here with Sailors manager Harry Noyes prior to a game in 1942, when the Sailors beat the police 7-6 in 11 innings. Jackie Tyler hit two home runs, and Ed "Shorty" Torello drove in the game-winning run. (Courtesy of Harry M. Noyes.)

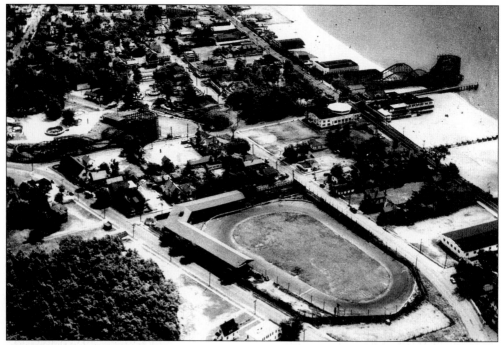

The Sailors began attracting more and more attention during the war years. Located right next to the Savin Rock Amusement Park, Donovan Field was in an ideal location for families looking for weekend entertainment. Trolley service brought people in from everywhere, and while Mom and the kids went to the amusement park, Dad could catch a ball game. (Courtesy of Bill Dorman.)

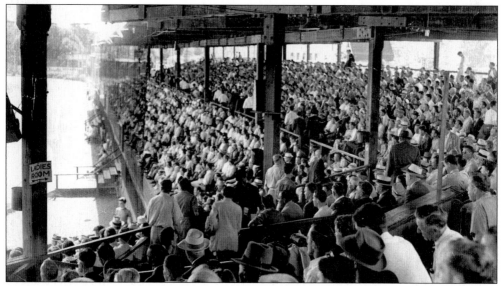

The Sailors left the Connecticut State League and operated independently during the war years, enabling them to bring in top opponents such as service teams and Negro League teams. Major League teams and players looking for an extra game also made appearances. Once the war ended, and with Donovan Field still packed, Quigley turned his attention to night baseball and opened up Exhibition Stadium nearby in 1947. (Courtesy of Harry M. Noyes.)

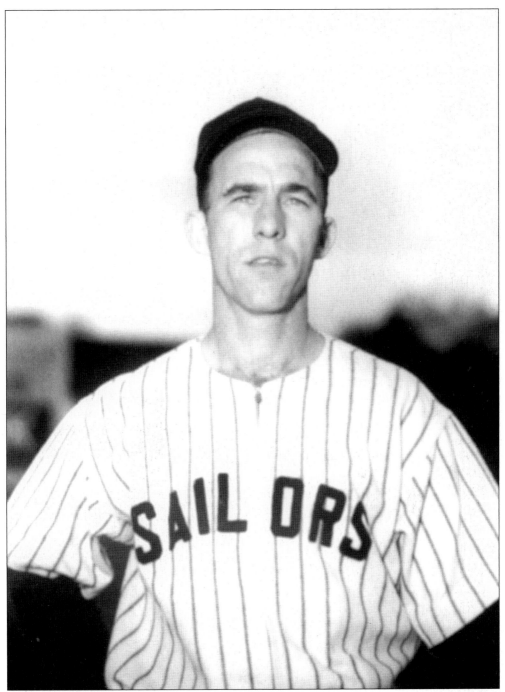

Shortstop Jackie Tyler went right from East Haven High School to the West Haven Sailors in 1939. He was voted the team's outstanding rookie. Amidst talk of a potential Major League career, Tyler had to alter his plans after the attack on Pearl Harbor. He served in the U.S. Navy for five years, and when he returned, his best baseball option was a return to the Sailors. He was named captain and served as a building block for the team's glory years in the late 1940s. (Courtesy of George Klivak.)

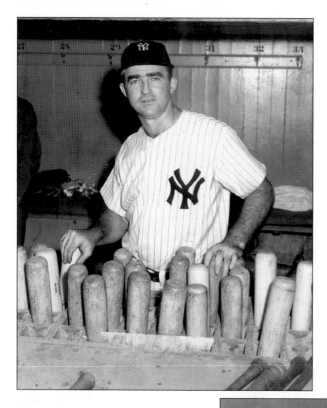

While World War II took many players away from the West Haven Sailors, owner Maurice Quigley was able to fill in the gaps with Major League players. A capacity crowd filled Donovan Field for the opening game of the 1944 season, with Billy Johnson playing shortstop for the Sailors. Just a few months earlier, Johnson had been with the New York Yankees in the World Series. Johnson wound up going 5-5 in West Haven's 4-1 win over the Stratford Chance-Vought Flyers. (Courtesy of the National Baseball Hall of Fame Library, Cooperstown, New York.)

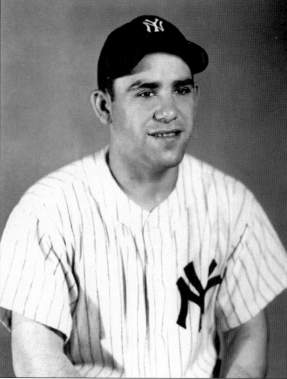

Stars that were not with big-league teams also came through—with teams from local military bases. Before he made it to the Yankees, Yogi Berra was a part of the New London Submarine Base team, which took on both Yale and the West Haven Sailors. (Courtesy of the National Baseball Hall of Fame Library, Cooperstown, New York.)

52

John White tied the Sailors home run record of 15 set by National Football League (NFL) star Ken Strong. A construction worker, White also helped Mo Quigley build Exhibition Stadium. Decades later, his cousin of the same name contributed to Yale's renovation of Yale Field. (Courtesy of George Klivak.)

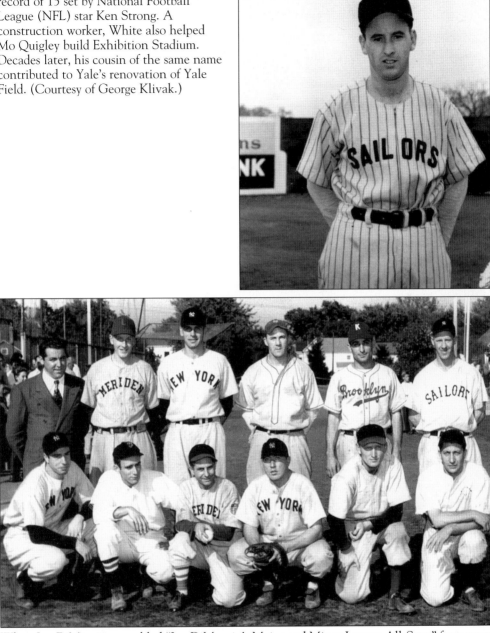

When Joe DiMaggio assembled "Joe DiMaggio's Major and Minor League All-Stars" for a game against the Hudson Valley Stars in Kingston, New York, in 1946, four West Haven Sailors were called upon to help round out the roster: Whitey Piurek, Jim Sheehan, Red Sheehan, and Bob Sperry. DiMaggio's team won 2-0. The star-studded roster included, from left to right, the following: (front row) Joe DiMaggio, Bob Repass, John Pullie, Snuffy Stirnweiss, Whitey Piurek, and Milt Rosner; (back row) Fred Davi, Bob Sperry, Randy Gumpert, Jim Sheehan, Carl Furillo, and Red Sheehan. (Photograph by Ken Roosa, Rosendale, New York, courtesy of Whitey Piurek.)

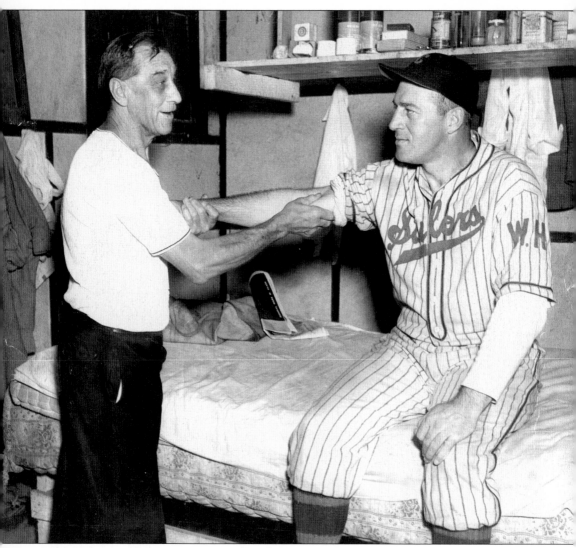

Shown here with trainer Moose Miller (left), Ken Strong had starred in baseball for West Haven High School and the New Haven Profs before turning to a professional football career with the New York Giants that eventually led him to the Hall of Fame. Strong returned to West Haven with the Sailors and put on a kicking exhibition during a war-bond rally at Donovan Field. Miller, who was also a trainer for Yale, was a story unto himself. He too had played professional ball in New Haven and often regaled the Sailors with stories from his playing days. In lieu of rubbing alcohol, he once gave Sailors pitcher George Klivak a rubdown using Hull's beer. "What difference does it make?" Miller reasoned. "It's got alcohol in it." (Courtesy of Harry M. Noyes.)

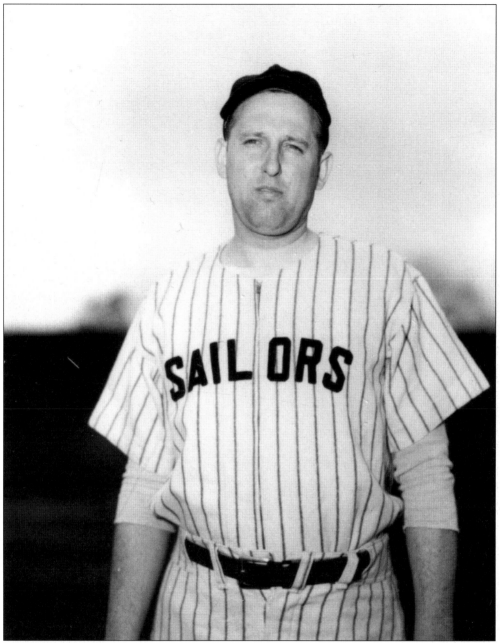

George "Ginger" Klivak signed with the Toronto Maple Leafs of the International League out of high school in 1938. After being drafted, Klivak was stationed at Manhattan Beach for the U.S. Coast Guard. He still found time to play ball, coming home on weekends to pitch for the Sailors and other local teams. He managed to win 18 games for West Haven one year. After the war ended, Klivak opted to stay in West Haven, where he had a comfortable job during the week and could also play for the Sailors in his spare time. Klivak was one of the Sailors' top pitchers and was called upon for a game in 1948 against the Birmingham Black Barons of the Negro League. Neither he nor his teammates could have known back then how significant that game would be. (Courtesy of George Klivak.)

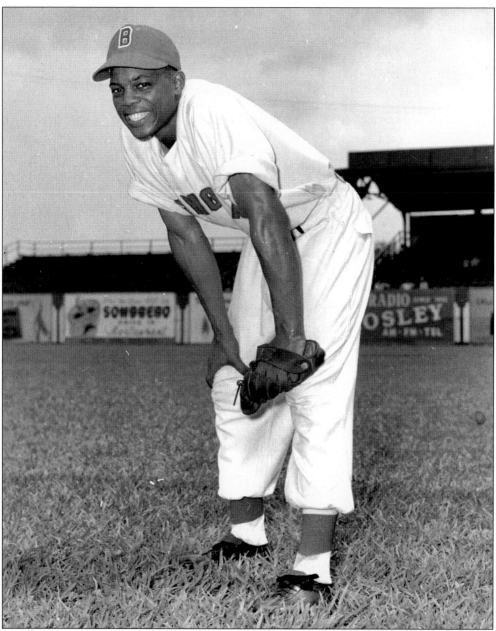

Sailors owner Maurice Quigley spotted a young man sitting with the Birmingham Black Barons during a pregame meal at his diner in 1948. "Who is that, the bat boy?" he asked. It turned out to be Birmingham's left fielder, 17-year-old Willie Mays. In the game against the Sailors later that day, Mays picked up two hits off Ginger Klivak and made a sensational catch. His career also nearly ended at Donovan Field. Mays crashed into a light tower in left field while trying to make a leaping catch of Vin Ventura's liner in the fifth. The shot went for a double, but attention quickly turned to the fallen Mays. After several minutes, he was able to remain in the game. The Sailors won that game 7-4; Mays and the Barons returned twice the following year, beating the Sailors 5-0 and 17-3. (Courtesy of the Memphis-Shelby County Public Library and Information Center.)

Francis "Huck" Finn had built an impressive baseball résumé by the time he joined the Sailors. Finn had been signed by George Weiss as a fourth outfielder for the New Haven Profs in 1930. After the Eastern League folded, he played on local teams, such as the Chevrolets, before joining the Sailors in the 1940s. He eventually got into coaching when he realized his playing days were coming to an end. "I was swinging too late for the first pitch and too early for the second," he joked. (Courtesy of Joan Finn-Bonci.)

New Haven native and Hillhouse High School graduate Bob Barthelson made it to the big leagues as a 19-year-old, pitching seven games for the New York Giants in 1944. After his professional career ended, he joined the West Haven Sailors and helped form the core of the pitching staff during the team's glory years. (Courtesy of George Klivak.)

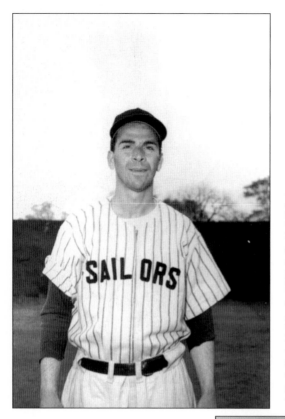

Joe Rossomando's graceful style in center field for the Sailors in the 1940s earned him comparisons to another Joe—DiMaggio. Coming out of West Haven High School, Rossomando had a promising professional career ended by a broken neck suffered in an outfield collision while he was with Los Angeles of the Pacific Coast League in 1945. During his final years with the Sailors, Rossomando joined the Yale staff as an assistant coach and went on to spend 35 years with the Bulldogs. (Left, courtesy of George Klivak; below, courtesy of the Yale Athletic Department Archives.)

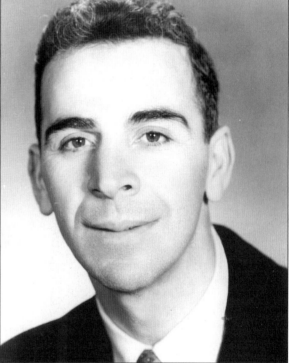

A crowd of 2,300 showed up at Exhibition Stadium on August 22, 1949, to see the New England Hoboes, whose combination of baseball and entertainment made them a popular draw. The show, however, was stolen—first by a dump fire beyond left field that caused the game to be halted for 30 minutes and then by Sailors first baseman Bob Sperry. The Hoboes had fought back from an early 4-1 deficit to get within 4-3 before Sperry blasted a long home run leading off the bottom of the sixth to put the game out of reach. (Courtesy of George Klivak.)

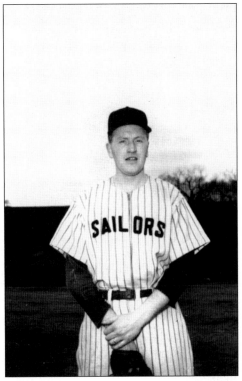

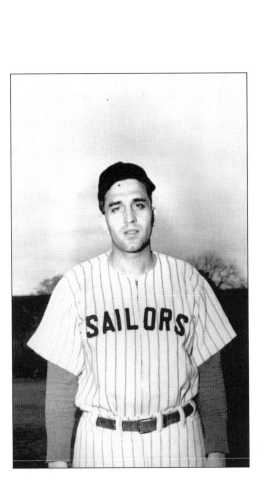

After the war, there were still many reminders that kept baseball in perspective. Teammates recalled seeing the scars on the back of Arnie Sergicomi in the locker room. The quiet, unassuming Sergicomi had been a prisoner of war in Germany. (Courtesy of George Klivak.)

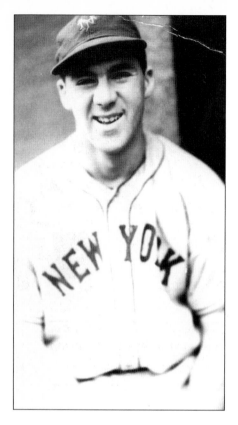

As a catcher with the New York Giants in 1936, New Haven native Jim Sheehan earned the confidence of Carl Hubbell. The Hall of Famer asked Sheehan to warm him up during a losing streak. Hubbell won his next game and continued to insist on warming up with Sheehan. Hubbell kept winning all the way to a record-setting 24 games in a row. After serving as an MP in Germany during World War II, Sheehan returned home to join his brother Red on the West Haven Sailors. (Courtesy of Jim Sheehan.)

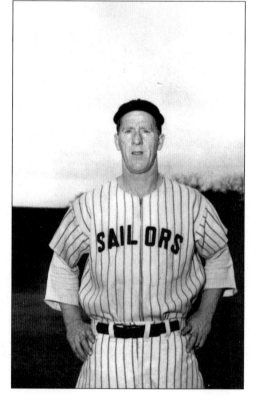

Red Sheehan is considered the greatest power hitter in Sailors history. His time with West Haven was interrupted only by his service in World War II, where he was part of the Battle of the Bulge. As his playing days came to a close, Sheehan helped start the local Little League in 1950. Sadly, he died of a cerebral hemorrhage that year at the age of 35. His brother Jim made sure that the Sailors did not cancel their next game: "Red wouldn't have wanted them to call the game off because of him." (Courtesy of George Klivak.)

Game programs went for 10¢ at Exhibition Stadium in 1949. Among the other items for sale at the park, Roessler's Red Hots in a Laconia roll went for 15¢, Pepsi-Cola cost 10¢, and Budweiser beer was the most expensive item on the menu at 30¢. Cigars (10¢ and 15¢) and cigarettes (25¢) were also sold at the park. (Courtesy of George Klivak.)

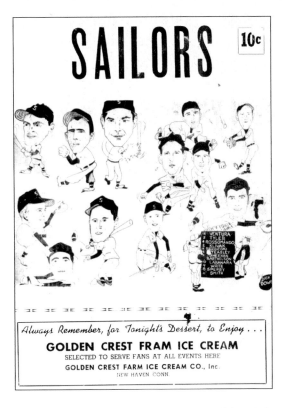

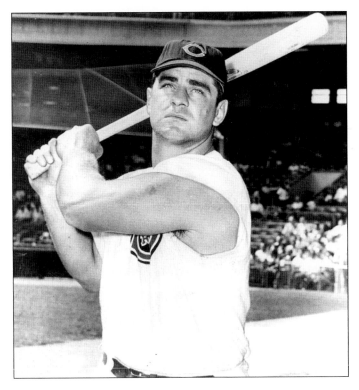

Ted Kluszewski and his Cincinnati Red teammates emphatically erased a 1-0 first-inning lead for the Sailors during their 1950 encounter. After scoring two in the fourth, Kluszewski's towering blast to right center field scored three more, and soon the rout was on. The Reds walked away with a 13-1 victory. The next day's *New Haven Register* simply said this of Kluszewski's blast: "It's still going." (Courtesy of the National Baseball Hall of Fame Library, Cooperstown, New York.)

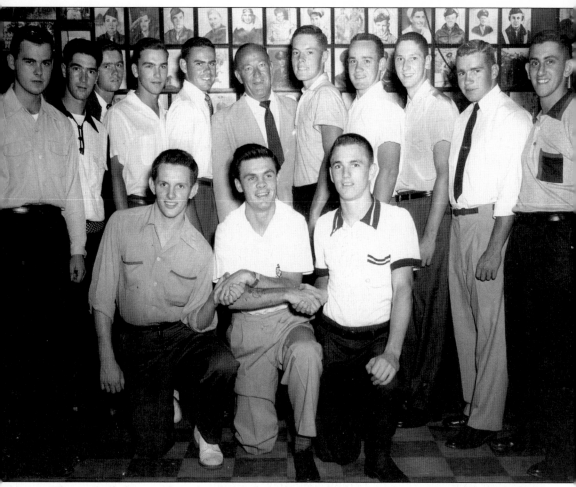

The end of the war brought about dramatic changes for the West Haven Sailors. With automobiles coming more into fashion, locals began sampling entertainment options far beyond Donovan Field and the Savin Rock Amusement Park. The booming interest in television also provided competition. The Sailors returned to the West Haven Twilight League. Here, the 1955 championship team poses at Quigley's Diner with photographs of war heroes lining the wall. Harry Noyes's son, Harry Noyes Jr., ran the team until joining the Marine Corps in 1956. With Noyes no longer around, the Sailors' era came to an end. (Courtesy of Harry M. Noyes.)

Five

WORLD SERIES
TO CITY SERIES

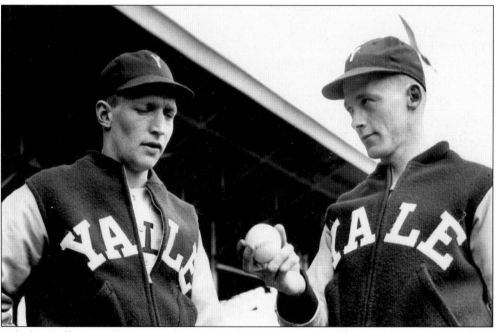

Yale baseball enjoyed a renaissance after the war. Here, Bulldog ace Frank Quinn (left) discusses pitching with Walt Gathman. While Gathman went on to pitch for the West Haven Sailors, Quinn attracted the attention of Major League scouts. In 1947, he set a team record for strikeouts with 149, including 20 in one game. After leading the Elis to the College World Series in 1948, Quinn signed with the Red Sox for a reported $60,000. He made it to the big leagues in 1949 for eight games but pitched just one more game the next year. Battling arm trouble, he was dealt to Washington and never made it back to the majors. (Courtesy of the Yale Athletic Department Archives.)

Former big-leaguer Ethan Allen was named Yale head coach on February 14, 1946, replacing Red Rolfe. Allen, who spent 12 seasons in the big leagues, had been in Italy as a member of the Army Special Services Forces before coming to Yale. He went on to lead the Elis for 22 years, surpassing Smoky Joe Wood as the winningest coach in Yale history with 333 victories. Allen's accomplishments included five Eastern Intercollegiate Baseball League titles and two NCAA World Series appearances. (Courtesy of the Yale Athletic Department Archives.)

Ethan Allen wrote dozens of books on baseball technique but was probably most famous as the man behind All-Star Baseball. The board game, which was produced annually from the 1940s into the 1990s, enabled fans to simulate a Major League game using a spinner and player cards. (Courtesy of the Yale Athletic Department Archives.)

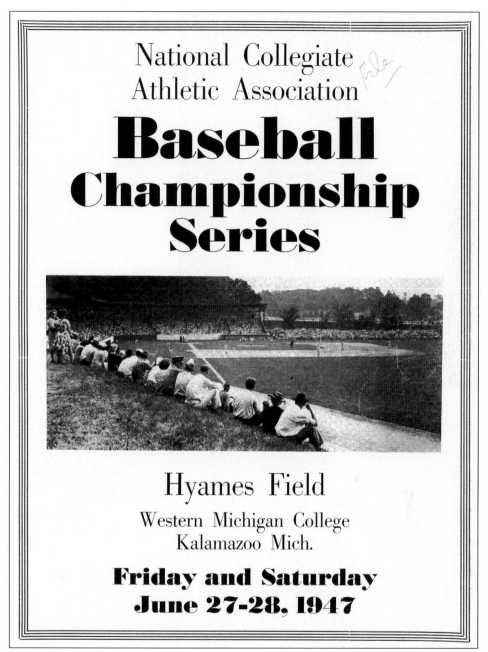

National Collegiate Athletic Association

Baseball Championship Series

Hyames Field

Western Michigan College
Kalamazoo Mich.

Friday and Saturday
June 27-28, 1947

Hoping to stir interest in college baseball, coaches Everett Barnes of Colgate and Joseph Bedenk of Penn State University started the American Association of College Baseball Coaches in 1944. California coach Clint Evans, the president of the association, came up with the idea for a tournament to determine a national champion. The College World Series was born in 1947, and the first-ever Eastern Regional took place at Yale Field. With a 7-3 win over Clemson and a 6-4 win over New York University, Yale advanced to the championship in Kalamazoo, Michigan. California broke open a 6-4 game with 11 runs in the ninth to win the opener 17-4. The Bears then claimed the best-of-three series by winning game two 8-7. (Courtesy of the Yale Athletic Department Archives.)

67

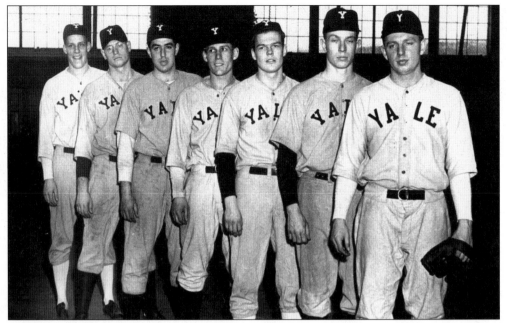

Jim Duffus (fifth from left) threw the first pitch of that first College World Series. He poses here with fellow Bulldogs (from left to right) Dick Manville, Phil Kemp, Sid Rosner, Vic Tataranowicz, Bob Goodyear, and Cotton Smith. Duffus was one of five players from Yale's 1948 team to sign a professional contract. That also included Manville, who made it to the major leagues for one game with the Boston Braves in 1950 and 11 games with the Chicago Cubs in 1952. (Courtesy of the Yale Athletic Department Archives.)

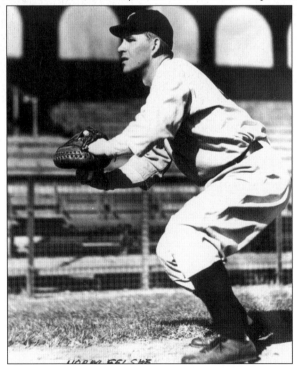

Norm Felske was the catcher for the first pitch of the first-ever College World Series, just one of many big games for him. Felske was also behind the plate for Frank Quinn's 20-strikeout game. He went on to play two years of professional ball after graduation, including a stint with the Eastern League's Hartford Chiefs. While with the Chiefs, Felske had the honor of catching the ceremonial first pitch at the first Little League World Series. (Courtesy of the Yale Athletic Department Archives.)

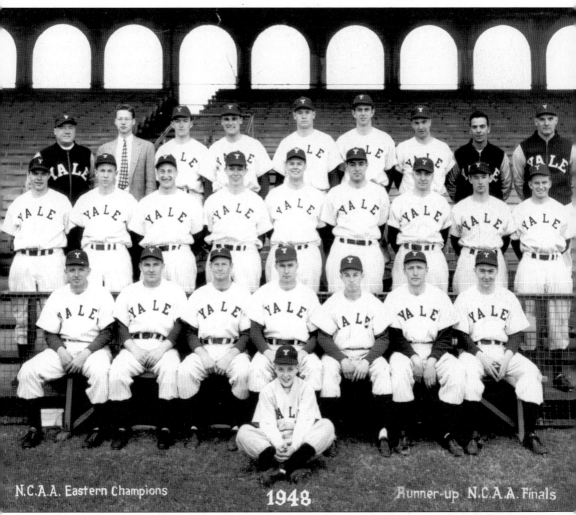

N.C.A.A. Eastern Champions 1948 Runner-up N.C.A.A. Finals

Yale returned to the College World Series in 1948 and swept through the Eastern Regional with a 6-1 win over North Carolina followed by two victories (11-2 and 4-3) over Lafayette. In the first game of the best-of-three championship in Kalamazoo against the University of Southern California, the Bulldogs lost in heartbreaking fashion. Yale led 1-0 heading into the top of the ninth, but two Bulldog errors enabled the Trojans to score three times. Still, Yale fought back to load the bases with no one out in the bottom of the ninth. With captain George H.W. Bush (front row, center) on deck, however, pinch-hitter Jerry Breen hit into a triple play. Yale tied the series with an 8-3 win in the first game of a doubleheader the next day, but the Trojans took the championship with a 9-2 win in the deciding game. (Courtesy of the Yale Athletic Department Archives.)

Following in the footsteps of his father (Prescott), George H.W. Bush held down first base for the Elis. Bush even got his wife, Barbara, involved, as she was frequently seen at games keeping score. As captain in 1948, Bush was already displaying his leadership skills. "One day, George, you're going to be President," head coach Ethan Allen told him. "And I'm not going to vote for you." (Courtesy of the Yale Athletic Department Archives.)

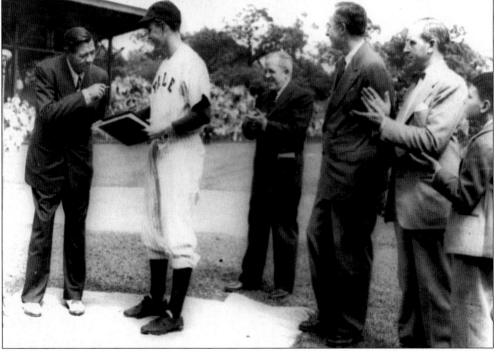

Ailing from throat cancer, Babe Ruth (left) made one of his last public appearances when he presented a copy of his biography to Yale on June 5, 1948, at Yale Field. George H.W. Bush (second from left) accepted the book on behalf of the university before passing it to librarian James T. Babb. The Babe hoarsely thanked the crowd of 6,000. A few days later, he was honored for the final time at Yankee Stadium. Ruth passed away on August 16. (Courtesy of the Yale Athletic Department Archives.)

Amidst rain showers at Cornell's Hoy Field on April 25, 1953, sophomore Bob Davis pitched the first no-hitter in the Ivy League. Davis pricked a blood blister on his throwing hand after the first inning and battled his control all game long, walking eight. He also struck out eight, however, and had only one close call. With two on and one out in the sixth, Cornell's Lee Morton hit a sinking line drive to left field. Bob Wahlers raced in to make the catch and then threw to second base for a double play. (Courtesy of the Yale Athletic Department Archives.)

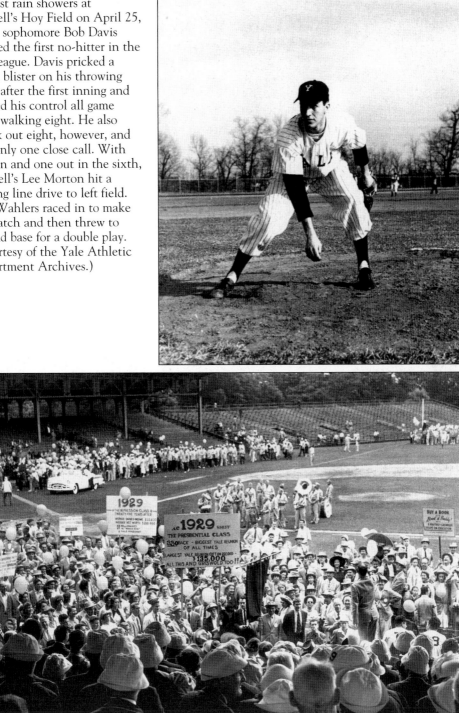

Reunion weekend crowds for Yale games remained strong through the 1950s. As interest waned in the 1960s, however, the games were discontinued, and the bleachers that had been in place to accommodate those crowds were removed. (Courtesy of the Yale Athletic Department Archives.)

After graduating from Yale in 1957, center fielder Ray Lamontagne had offers from a half-dozen Major League teams, offering signing bonuses upwards of $50,000. Lamontagne had other plans, however. Trips abroad after his freshman and junior years convinced him his true calling was helping others. As leader of an undergraduate group devoted to aiding foreign students, Lamontagne was put in charge of devising an English language program for 12 Hungarian refugees. Unable to find a Hungarian dictionary in New Haven, he flew to New York and spent a weekend visiting libraries and language schools. He returned to Yale and spent two months teaching the refugees by day and learning Hungarian from a tutor in New York at night. After graduation, he enrolled in the Yale-in-China program to teach English to Chinese refugees in Hong Kong. (Courtesy of the Yale Athletic Department Archives.)

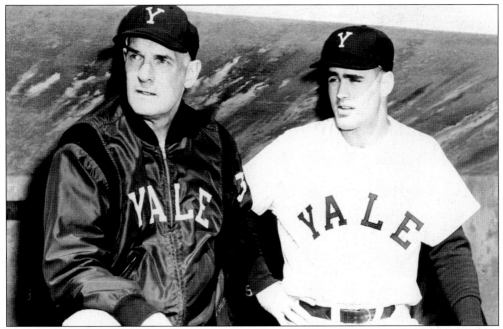

Shown with head coach Ethan Allen, 1962 Yale captain Ruly Carpenter (right) entered the family business after graduating; his family owned the Philadelphia Phillies. Carpenter started in the Phils' financial department, moved on to work in the farm system, and eventually took over as president. He sold the team to a group headed by Bill Giles in 1981. "I'm going to write a book," Carpenter once joked. "How to Make a Small Fortune in Baseball—you start with a large fortune." (Courtesy of the Yale Athletic Department Archives.)

The 1960s saw other local college baseball programs emerge to share the spotlight with Yale. In 1961, West Haven Twilight League veteran Art Ceccarelli returned to Southern Connecticut State College to get his degree and, in 1966, came on board as a coach. Ceccarelli had spent parts of five different seasons in the Major League, appearing in 79 games with the Kansas City Athletics, Baltimore Orioles, and Chicago Cubs. (Courtesy of Art Ceccarelli.)

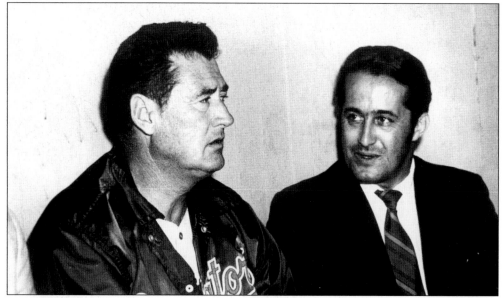

New Haven College coach Frank Vieira (right) greets Ted Williams in the dugout at Yankee Stadium. Vieira, who had worked Williams's baseball camp in Lakeville, Massachusetts, joined the New Haven coaching staff in 1963 as a physical education teacher and assistant basketball coach. He was also put in charge of fielding the school's first baseball team. He led the team to a 16-3-1 record that first year and went on to win more than 1,000 games, leading his teams to 15 trips to the Division II College World Series. (Courtesy of the University of New Haven.)

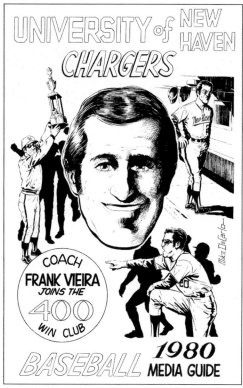

New Haven celebrated Vieira's 400th victory on its 1980 media guide cover. (Courtesy of the University of New Haven.)

Like his father and grandfather before him, George W. Bush played baseball when he came to Yale in 1964. After one season on the freshman team, however, he turned his attention elsewhere. Baseball remained a big part of his life, including a stint as owner of the Texas Rangers in the 1990s. He also became the first U.S. president to attend the College World Series, doing so in 2001. (Courtesy of the Yale Athletic Department Archives.)

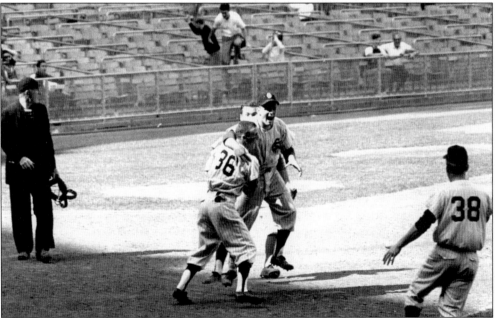

Catcher Tony Ginnetti scored the winning run at Yankee Stadium as Southern Connecticut State College beat Oswego State 2-1 for the 1966 Atlantic Coast championship. With two out in the bottom of the ninth, Ginnetti—whose passed ball had allowed Oswego to score its only run—tripled. Harvey Melzer then delivered a line-drive single to center field on a 1-2 pitch for the winner. (Courtesy of Southern Connecticut State University Sports Information.)

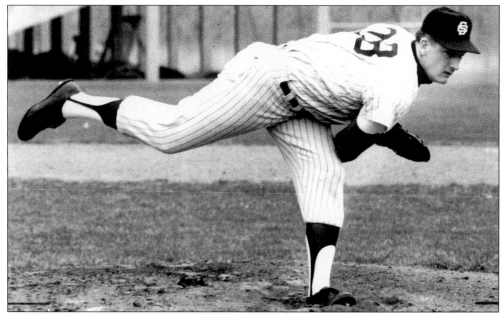

Southern Connecticut State pitcher Bob "Rusty" Brooder allowed just 27 walks and 17 earned runs in 162$\frac{1}{3}$ innings from 1965 to 1967, posting a 0.94 ERA. Brooder's best season came in 1967, when he threw five shutouts and allowed only two earned runs in 61$\frac{1}{3}$ innings for a 0.29 ERA. (Courtesy of Southern Connecticut State University Sports Information.)

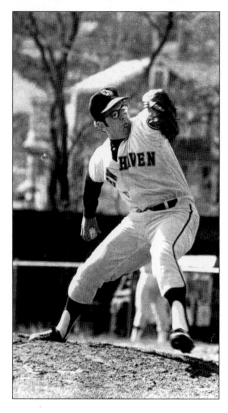

New Haven College's Dave Wallace registered 311 strikeouts for his career, second on the school's all-time list. He also won 24 games and posted a 2.18 ERA. Wallace signed with the Philadelphia Phillies in 1969, making it to the big leagues in 1973. He then moved on to a successful career as a big-league pitching coach. (Photograph by Mike Stern, courtesy of the University of New Haven.)

After a six-year Major League career, former Yale captain Ken MacKenzie returned to his alma mater as head coach in 1969. He had crossed paths with fellow Yalie George Weiss while pitching for the Mets. MacKenzie, bargaining for a raise from Weiss, noted that he "just found out that [he was] the lowest paid member of the Yale Class of 1956." A member of the notoriously bad 1962 Mets, MacKenzie recalled manager Casey Stengel's advice to him while pitching to opposing batters: "Make like they're the Harvards." Once MacKenzie became head coach at Yale, he helped rattled Bulldog pitchers deal with opposing batters by advising them, "Make like they're the Mets." (Courtesy of the Yale Athletic Department Archives.)

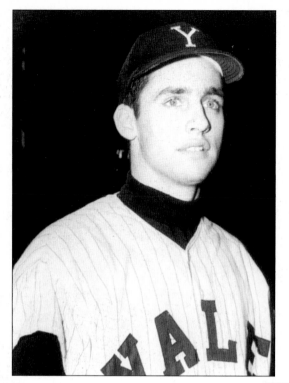

One of MacKenzie's early stars at Yale, Brian Dowling was known for more than his baseball ability. He went undefeated as a quarterback both in high school and at Yale and inspired the character B.D. in fellow Yalie Garry Trudeau's comic strip *Doonesbury*. Success came more slowly for Dowling on the diamond; he hit just .216 as a sophomore. In his senior year of 1969, however, he finished second on the team with a .305 mark. (Courtesy of the Yale Athletic Department Archives.)

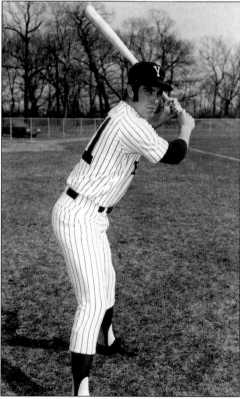

The leading rusher for Yale's football team, Dick Jauron endured some ups and downs on his way to being named captain of the 1973 baseball team. Jauron hit just .176 as a sophomore and .208 as a junior but busted out his senior season with a team-best .324 average, 7 doubles, and 16 RBIs. Drafted in the fourth round of the 1973 NFL draft by the Detroit Lions, Jauron developed into a Pro Bowl–caliber defensive back and played nine seasons in the NFL before becoming a coach. (Photograph by Sabby Frinzi, courtesy of the Yale Athletic Department Archives.)

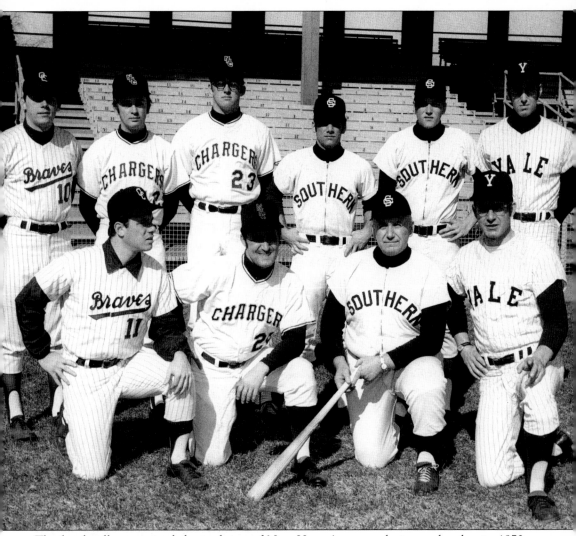

The local colleges revived the tradition of New Haven's teams playing each other in 1970. Quinnipiac, New Haven, Southern Connecticut, and Yale gathered at Yale Field for their first City Series. In the front row are, from left to right, coaches Harry Brown of Quinnipiac, Frank Vieira of New Haven, Gene Casey of Southern Connecticut, and Ken MacKenzie of Yale. In the back row are, from left to right, Dan Gooley of Quinnipiac, Neil Olson and John Krawiecki of New Haven, Jeff Videtto and Glenn Poveromo of Southern, and Steve Greenberg of Yale (the son of big-leaguer Hank Greenberg). Led by three hits and two RBIs from Videtto, Southern Connecticut State went on to beat New Haven 6-1 to win the series. Quinnipiac and New Haven both went on to make the National Association of Intercollegiate Athletics tournament. (Photograph by Sabby Frinzi, courtesy of the Yale Athletic Department Archives.)

79

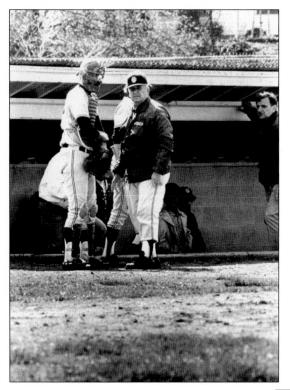

Longtime Southern Connecticut coach Gene Casey consults with his catcher in a game at New Haven's Bowen Field. Casey was the Owls' head coach for 14 seasons, retiring in 1975 with a record of 175-92-2. (Courtesy of Southern Connecticut State University Sports Information.)

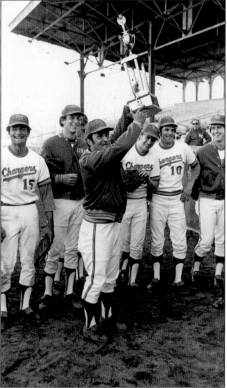

New Haven coach Frank Vieira celebrates winning the 1975 City Series at Yale Field. The Chargers beat Quinnipiac 11-3 in the opener and then rallied from a 4-0 deficit to edge Southern Connecticut 5-4 in 10 innings for the title. It was New Haven's fourth title in the tournament's first six years. (Courtesy of the University of New Haven.)

Six

HERE COME
THE YANKEES

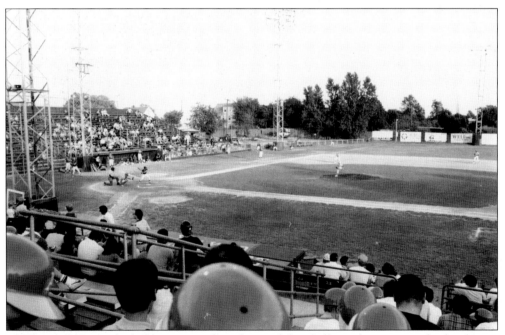

The year 1972 marked the return of professional baseball to the area, with the former Exhibition Stadium (by then named after Maurice Quigley) as the site. Owner Ron Duke moved his Eastern League team from Manchester, New Hampshire, to West Haven. The move was an immediate success. After drawing just 28,981 fans in the final season in Manchester, the Yankees drew 102,537 in their first season in West Haven. (Photograph by Bill O'Brien.)

The parent New York Yankees were intent on making their new West Haven affiliate a success on the field as well. In addition to overhauling the roster, the Yankees replaced manager Mickey Vernon with 30-year-old former third baseman Bobby Cox, who had managed the team's Single-A Fort Lauderdale affiliate in 1971. Cox and the West Haven Yankees steamrolled through the Eastern League's North Division, winning it by 17 1/2 games with an 84-56 record. They then swept the South champion Trois Rivieres Aigles 3-0 for the championship. Cox moved up to Triple-A the next year and was in the big leagues as the Yankees' first-base coach by 1977. He began his Major League managerial career with the Atlanta Braves the following season. (Photograph by Bob Dixon, courtesy of Ron Duke.)

Southern Connecticut State shortstop Paul Baretta proved to be one of the key players for the 1972 West Haven Yankees. The five-foot five-inch Baretta, who had played at Quigley Stadium in the Connecticut Collegiate Baseball League, struck out just 27 times all season while drawing 64 walks. (Courtesy of Southern Connecticut State University Sports Information.)

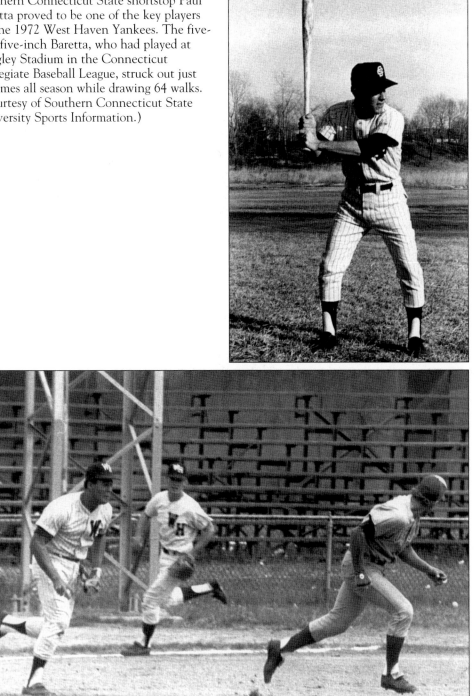

Infielder Otto Velez (left) quickly became a favorite with the fans, who enjoyed chanting his first name. He also had the key hit in the first game of the 1972 Eastern League championship series, breaking a scoreless tie in the 16th inning with an RBI double for a 1-0 win at Trois Rivieres. (Photograph by Bob Dixon, courtesy of Ron Duke.)

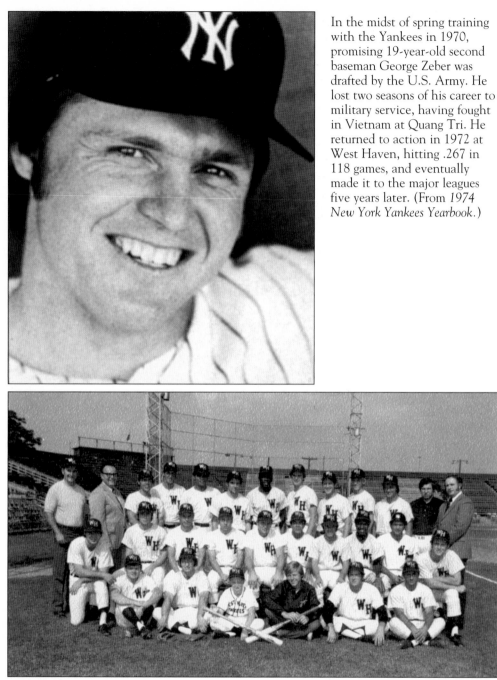

In the midst of spring training with the Yankees in 1970, promising 19-year-old second baseman George Zeber was drafted by the U.S. Army. He lost two seasons of his career to military service, having fought in Vietnam at Quang Tri. He returned to action in 1972 at West Haven, hitting .267 in 118 games, and eventually made it to the major leagues five years later. (From *1974 New York Yankees Yearbook*.)

Doc Edwards (middle row, fourth from left) took over the Yankees in 1973 with the promotion of Bobby Cox to Triple-A. Grady Little (front row, second from right) was a pupil of Edwards and Cox. A light-hitting catcher, Little started his coaching career with West Haven. Cox wound up bringing Little with him to the Atlanta Braves organization in 1986, where Little took the Braves' Pulaski affiliate to a league title. Little racked up more than 1,000 victories as a Minor League manager before being named manager of the Boston Red Sox in 2002. (Photograph by Bob Dixon.)

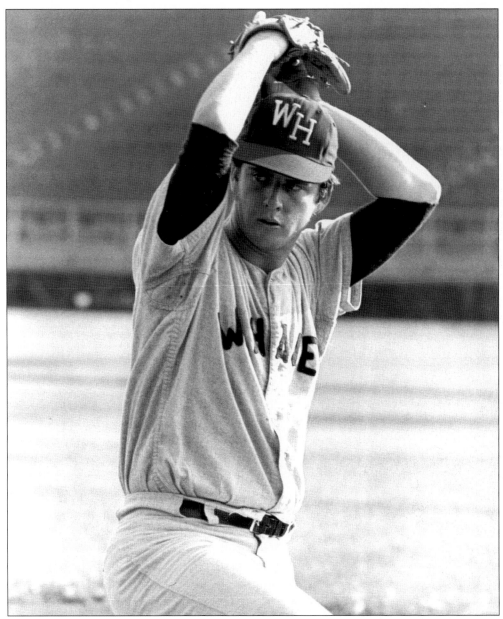

Scott McGregor had turned 19 just a few months before drawing the start for West Haven on opening day of 1973. McGregor, the New York Yankees' top draft choice in 1972, signed for $85,000 but did not receive any star treatment from his teammates. "As far as most of us are concerned, Scotty's just one of the guys," catcher Bill Stearns said. "We light his shoelaces just like we do everyone else's." McGregor went 12-13 with a 3.29 ERA that season. He and Otto Velez were the two players that Oakland Athletics owner Charles O. Finley asked for as compensation when the Yankees attempted to hire Athletics manager Dick Williams. The Yankees wound up passing on that deal but traded McGregor to the Baltimore Orioles in 1976 along with Rudy May, Tippy Martinez, Dave Pagan, and Rick Dempsey for Ken Holtzman, Doyle Alexander, Grant Jackson, Elrod Hendricks, and Jim Freeman. McGregor went on to win 138 games in a 13-year career with the Orioles. (Photograph by Bob Dixon.)

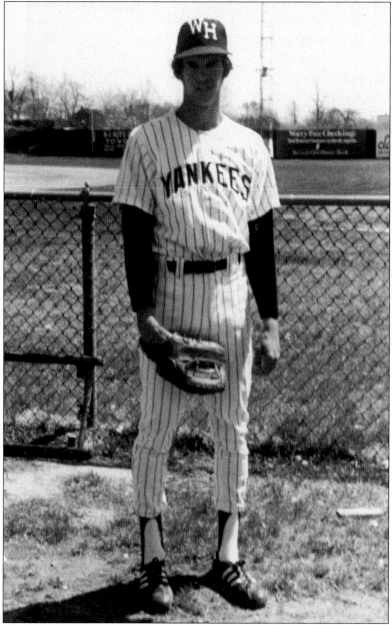

Ron Guidry arrived in West Haven with little fanfare as a skinny left-handed reliever who even saw action in the outfield for one game. By the All-Star break, manager Doc Edwards was ready to give him a shot at the starting rotation; still, Guidry ended the season with an unimpressive 5.26 ERA. He made it to the major leagues for 10 games in 1975 and 7 in 1976 before finally establishing himself with a 16-win season in 1977. In his biography, Guidry recalled one particular incident while at West Haven. The team bus rolled to a stop after its engine died on the way back from Trois Rivieres. In the middle of the night, the team scrambled to find a hotel. When they went back to the stalled bus the next morning, they saw that it had stopped rolling just a few feet from a cliff. If the bus had continued to roll any farther, it would have tumbled several hundred feet into the St. Lawrence River. (Courtesy of Jean Kaas.)

The contributions of those involved with the West Haven Yankees off the field did not go unnoticed. One of the team's biggest supporters was the Kaas family. The family's generosity in hosting the players was reflected in the many mementos they left behind for Jean "Mama" Kaas, including a bat that catcher Dennis Werth made into a lamp. Kaas even wrote a book about her experiences, *Minor League Mama*, in which she explained the appeal of her family's postgame Sunday meals for the team: "We are blessed with having a home which lends itself to making people feel comfortable, a large yard which easily converts to a whiffle-ball diamond and an immediate proximity to the ocean which commands a great deal of leisure-time pleasure. We have never played formal 'host and hostess.' We point the way to the beer and soda, put out plenty of post-game 'pickings,' such as fresh fruit, cheese or popcorn, turn on the television and disappear to the kitchen to prepare a plain but bountiful meal." (Courtesy of Jean Kaas.)

The year 1977 marked a change in ownership for the West Haven franchise, as Lloyd Kern and University of New Haven graduate Robert Zeig took over the team. The two revamped the team's promotional schedule and added a mascot known as Yankee Frankie in 1978. Capitalizing on Frankie's popularity, the team made plans to introduce a female mascot, Yankee Francine, the following year. (From *West Haven Yankees 1979 Official Scorebook & Magazine*, courtesy of Tony Occhineri.)

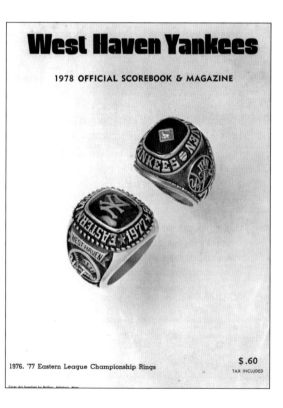

West Haven Yankees

1978 OFFICIAL SCOREBOOK & MAGAZINE

1976, '77 Eastern League Championship Rings

$.60
TAX INCLUDED

By 1978, championships had become a regular occurrence in West Haven. The team swept Trois Rivieres again in 1976 and 1977, proudly displaying the accompanying rings on the 1978 game program. (Courtesy of Tony Occhineri.)

Carl "Stump" Merrill was the West Haven Yankees' pitching coach in 1977 and then made his managerial debut in 1978. He led the team to the best overall record in the Eastern League (82-57), but because the league divided the season into two halves (and West Haven did not win either half), the team did not even make the playoffs. Merrill returned as manager in 1979, and the team claimed the Eastern League championship by winning both the first and second halves of the season. (From *West Haven Yankees 1979 Official Scorebook & Magazine*, courtesy of Tony Occhineri.)

Acquired by the Yankees from Texas in a 10-player trade that included Sparky Lyle the previous November, Dave Righetti made the West Haven team's opening-day roster in 1979 at the age of 20. He dominated Eastern League batters to the tune of a 1.96 ERA with 78 strikeouts in 69 innings pitched, earning All-Star recognition. He made a brief stop in Triple-A Columbus before making his Major League debut later that season. (Courtesy of Jean Kaas.)

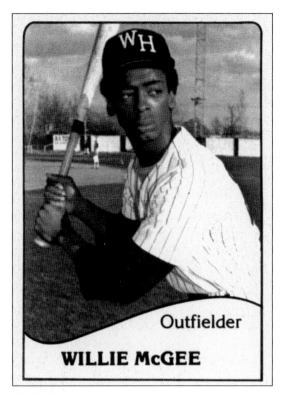

Outfielder

WILLIE McGEE

Willie McGee's stay in West Haven was not as successful. Hitting .243 through 49 games in 1979, McGee was sent back to Single-A Fort Lauderdale. Two years later, after being traded to St. Louis for Bob Sykes, McGee remarked that he had two chances of winning a job with the Yankees: "slim and none." He then helped the Cardinals win the 1982 World Series. (Courtesy of TCMA.)

Signs of leadership were evident early in Buck Showalter, who was elected captain of the West Haven Yankees in 1979. After his playing career ended in 1983, he spent one year as a coach with the Yankees' Single-A Fort Lauderdale affiliate and then began a five-year stint as a Minor League manager in the Yankees' chain—including a return to the Eastern League, where he led the Albany-Colonie Yankees to the title in 1989. He moved up to the major leagues the following year as a coach and, in 1992, took over as Yankees manager. (Courtesy of TCMA.)

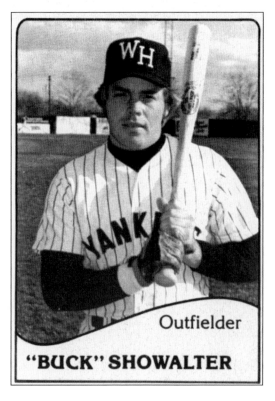

Outfielder

"BUCK" SHOWALTER

After the 1979 season, the New York Yankees switched their Double-A affiliate to Nashville. West Haven owners Lloyd Kern and Bob Zeig, no longer able to call the team the Yankees, briefly revived the name "West Haven Sailors." Before the team even took the field, however, Kern and Zeig moved it to Lynn, Massachusetts. The Eastern League acted quickly to keep baseball in West Haven for 1980, moving the Athletics affiliate over from Waterbury. That meant a new name, the White Caps, and a new manager, Ed Nottle. It also meant coping with the penurious ways of Oakland owner Charles O. Finley, who refused to invest in his team's farm system. At one point, the White Caps were so short of players that Nottle had to activate himself. (Courtesy of TCMA.)

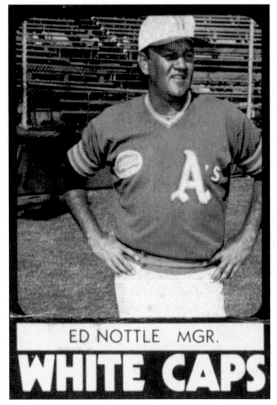

ED NOTTLE MGR.

WHITE CAPS

Warren Spahn made an appearance at Quigley Stadium while working with the pitchers for the Holyoke Millers, the California Angels' Eastern League affiliate. Decades earlier, Spahn had pitched against the West Haven Sailors in the same place when it was known as Exhibition Stadium. (Photograph by Bill O'Brien.)

91

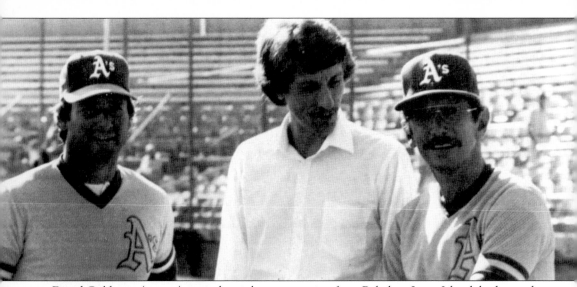

David Goldstein (center), an industrial representative from Babylon, Long Island, had won the bidding as the new owner of West Haven's Eastern League team for 1980. After one season as the White Caps, the team took the name of its Major League affiliate, the Athletics. Struggling without the appeal of being a Yankees affiliate, the team played off a former Yankee: Oakland Athletics manager Billy Martin (right), who poses here with Goldstein and West Haven manager Bob Didier. Still, attendance dropped precipitously. The team was eventually sold and moved to Albany, New York. West Haven went out a winner, however, sweeping Lynn for the 1982 Eastern League championship in its final season. (From *West Haven A's 1981 Souvenir Scorebook-Magazine*, courtesy of Bill O'Brien.)

Seven

THE COLLEGE GAME

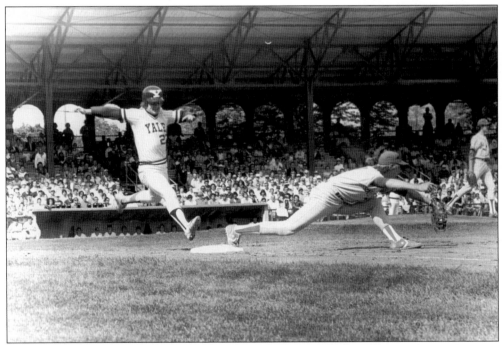

Author Roger Angell arranged to watch the 1981 NCAA Northeast Regional game between Yale and St. John's with former Eli coach Smoky Joe Wood. Angell corrected himself after noting that the stands at Yale Field were half empty. "Call them half full," he wrote in *Late Innings*, "because everyone on hand—some twenty-five hundred fans—must know something about the quality of the teams here, or at least enough to qualify either as a partisan or as an expert, which would explain the hum of talk and expectation that runs through the grandstand." (Photograph by Sabby Frinzi, courtesy of the Yale Athletic Department Archives.)

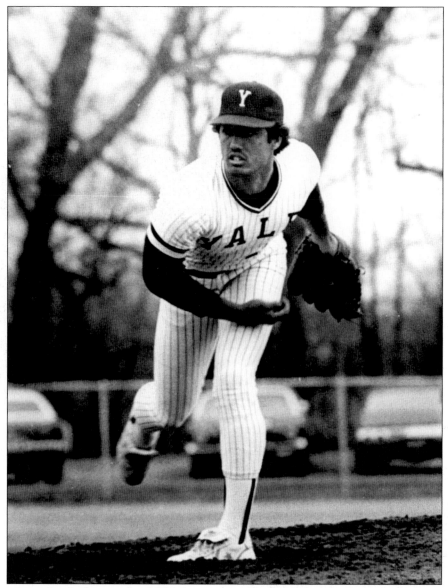

A big reason for the hum at that NCAA game was that Yale's Ron Darling was on the mound. Darling had attracted the attention of Major League teams as a potential No. 1 draft pick. More than 50 scouts showed up to watch him take on St. John's ace Frank Viola. Darling responded by no-hitting the Redmen for 11 innings, but the Bulldogs went scoreless against Viola. St. John's finally broke up the no-hitter on a bloop single by Steve Scafa in the 12th. With two outs and runners on first and third later that inning, the Redmen executed a delayed double-steal. Darling threw a slider, which left him falling off the mound and unable to cut off catcher Tony Paterno's throw to second. Second baseman Jeremy Spear grabbed the ball and began running Tony Covino of St. John's back to first. As Spear threw to first baseman Brien O'Connor to try to get Covino, Scafa took off for home. He beat O'Connor's throw for a 1-0 lead. Eric Stampfl came on in relief of Viola in the 12th to close out the victory. Darling, who finished with 16 strikeouts, later went in the first round of the draft to the Texas Rangers. (Photograph by Sabby Frinzi, courtesy of the Yale Athletic Department Archives.)

Center fielder Rich Diana was also a key part of that Yale team, hitting .341 with a team-best 8 home runs and 43 RBIs. Diana also had an excellent football career and led Yale in rushing in both 1980 and 1981. He wound up getting drafted by the Miami Dolphins in the fifth round of the 1982 NFL draft. (Photograph by Sabby Frinzi, courtesy of the Yale Athletic Department Archives.)

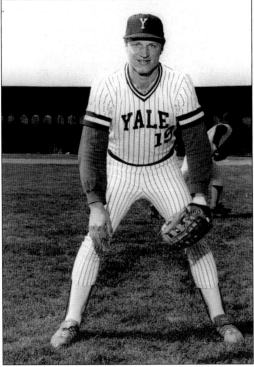

Joe Dufek was another player who made an instant impact on the Eli fortunes, hitting .306 as a freshman in 1980. The 6-foot 4-inch, 220-pound Dufek developed into one of the top hitters in the league, setting a Yale record with a .447 batting average in 1983. Also a quarterback, Dufek wound up playing three seasons in the NFL. (Photograph by Sabby Frinzi, courtesy of the Yale Athletic Department Archives.)

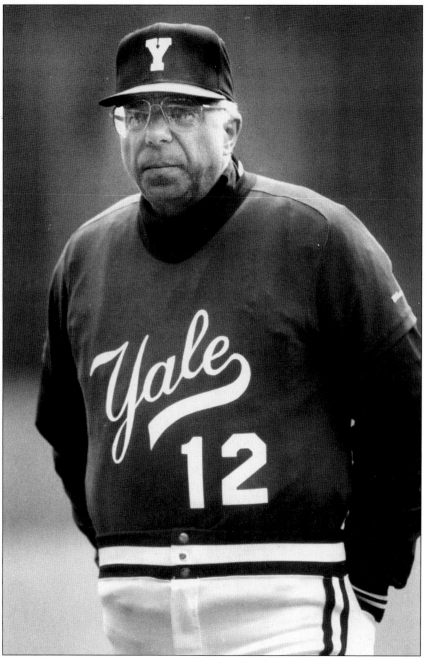

Seven years after leading Shelton High School to victory in the Class L state championship game at Yale Field, Joe Benanto returned—as Yale's head coach. Hired on an interim basis in 1979, he went on to coach the Bulldogs for 13 years. Taking over a team that had gone 7-27 the previous year, Benanto led the Bulldogs to a 14-16 record in his first year. The turnaround continued in 1980, with the team posting a 21-11 record. In 1981, Yale claimed its first Eastern Intercollegiate Baseball League title in 24 years with a 24-14-1 mark, making the NCAA tournament for the first time since 1948. (Photograph by the New Haven Register, courtesy of the Yale Athletic Department Archives.)

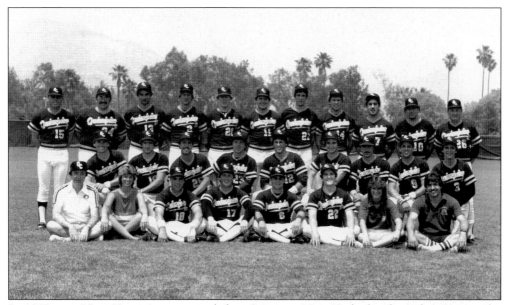

In 1983, two New Haven teams traveled to Syracuse, New York, for the right to go to the NCAA Division II World Series. Quinnipiac wound up beating the University of New Haven to advance. Junior right-hander Tom Signore picked up a win in relief on Friday night against C.W. Post in the first round and then won both ends of a doubleheader sweep of New Haven, which got Quinnipiac to the World Series. (Photograph by Gaines Du Vall Sports Portraits, courtesy of Quinnipiac University.)

The Braves drew powerful Florida Southern in the opening round. The five-time champions jumped out to a 5-0 lead over Quinnipiac in the first en route to a 13-1 win. In the next game, against Southern Illinois-Edwardsville, Quinnipiac fell behind 2-0 in the first but fought back to take a 3-2 lead in the second. The Cougars tied the game in the fifth and then went ahead 8-3 with a four-run seventh and a solo run in the eighth. Quinnipiac made things interesting in the ninth, scoring three times and loading the bases with one out. A pop-up and a strikeout ended Quinnipiac's NCAA run. (Courtesy of Joe Yotch.)

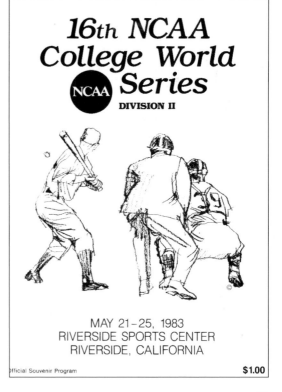

16th NCAA College World Series

NCAA

DIVISION II

MAY 21–25, 1983
RIVERSIDE SPORTS CENTER
RIVERSIDE, CALIFORNIA

Official Souvenir Program $1.00

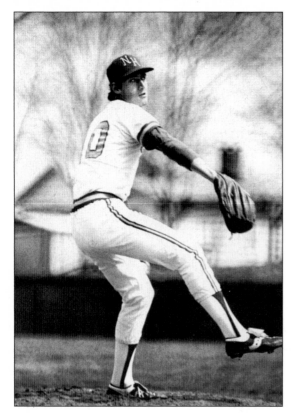

The University of New Haven's Mike Raczka finished his career with a school-record 312 strikeouts, one more than Dave Wallace. Raczka, an All-American, was also named the school's male athlete of the year in 1984. His 145 strikeouts that year were one short of the school single-season mark, held by Rich Anderson. He helped lead New Haven to the NCAA Division II World Series that year, the start of a stretch of seven straight seasons in which the Chargers made it to the series. (Courtesy of the University of New Haven.)

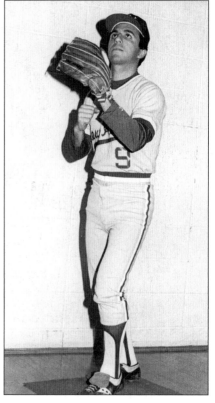

Roberto Giansiracusa's .415 batting average for the University of New Haven in 1984 earned him All-American and All-Northeast Region honors. Ranked in the school's career top 10 in batting average (.382), base hits (190), doubles (34), and home runs (17), Giansiracusa signed with the Philadelphia Phillies organization in 1985. (Courtesy of the University of New Haven.)

Recruited as a basketball player, Cameron Drew developed into one of the University of New Haven's top baseball players. Drew was given All-Northeast Region honors in 1985, hitting .388 and helping the Chargers to the NCAA Division II World Series. He was then selected in the first round of the draft by the Houston Astros, making him the highest pick in school history. He made it to the big leagues in 1988. (Courtesy of the University of New Haven.)

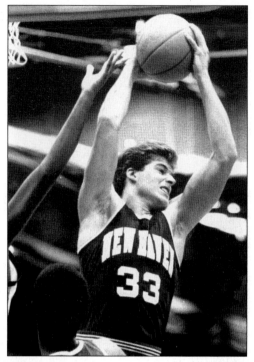

Steve Bedrosian, shown celebrating his 1987 National League Cy Young Award, made the most of his one season with the University of New Haven after transferring from a junior college in 1978. "Bedrock" went 13-3 with three saves, earning All-American honors and helping the Chargers to their first-ever NCAA Division II World Series championship game. (Photograph by the Philadelphia Phillies, courtesy of the University of New Haven.)

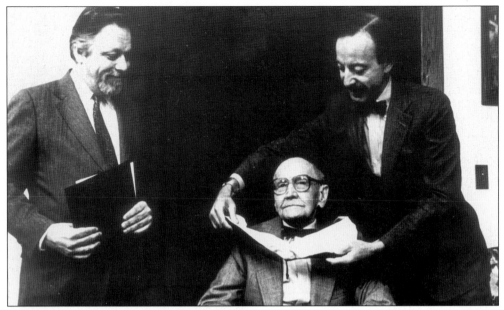

Yale continued to produce individuals who made contributions to baseball beyond the playing field. University president Bart Giamatti (left), shown here along with university secretary John Wilkinson (right) presenting a doctor of humane letters degree to Smoky Joe Wood, was named president of the National League in June 1986. (Courtesy of the Yale Athletic Department Archives.)

One of Giamatti's first hires as president of the National League was Yale physics professor Robert K. Adair. Knowing that Adair was a huge baseball fan, Giamatti created a position for him as the first-ever "physicist to the National League." Adair turned his work into a book, *The Physics of Baseball*, in 1989. Former Yale first baseman George H.W. Bush autographed a photograph of himself reading the book in the White House for Adair. "If only I had read this 44 years ago, I might have batted .300," he wrote. (Courtesy of Harper Collins.)

Captain John Brandt led Yale in batting (.350) in 1989 and then took a unique route back to Yale Field. Brandt received a master's degree in hospitality administration from Johnson and Wales University after graduation. When New Haven was awarded a Double-A Eastern League expansion franchise in 1992, he took over as the team's first-ever concession manager. (Courtesy of the Yale Athletic Department Archives.)

Injuries hampered Notre Dame of West Haven star Adam Schierholz throughout his Yale career, including a torn elbow ligament that cost him most of his senior year in 1987. However, Schierholz had picked up some managerial experience while with the Bulldogs—he coached the junior varsity team while he was injured his junior year. Schierholz returned to Yale Field 15 years later as general manager of the New Haven Ravens, the Minor League team that shares the facility with Yale. (Courtesy of Adam Schierholz.)

TURK WENDELL

Steven "Turk" Wendell attracted the attention of big-league scouts while at Quinnipiac, where he worked three jobs as a sophomore just to make ends meet. After pitching 15 innings (and losing) in an NCAA Regional game in 1988, Wendell went in the fifth round of the draft to the Atlanta Braves. He made it to the Major League five years later with the Chicago Cubs and sent this memento back to one of his former coaches, Joe Yotch. (Courtesy of Joe Yotch.)

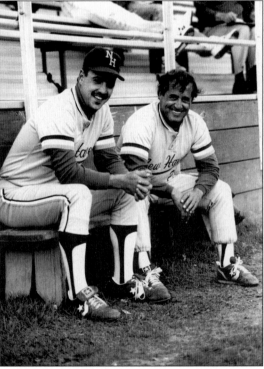

Shown with head coach Frank Vieira, the University of New Haven's Steve DiBartolomeo (left) earned National Division II Player of the Year honors in 1989. "DiBo" went 17-1 with a 1.92 ERA, adding 133 strikeouts and 7 saves. He finished his career with a 43-4 record, signing with the Chicago Cubs organization. (Courtesy of the University of New Haven.)

Another one of the baseball-playing Riccios, Ray Riccio made his mark at Quinnipiac (where his brother Andy had been a part of the 1983 College World Series team) with 115 career hits. In one 1989 game, a ninth-inning error by Ray cost his brother Dave a save against Southern Connecticut State. Ray, however, started the game-winning rally in the bottom of the ninth to make his brother the winning pitcher. (Courtesy of Quinnipiac University.)

Joe Lucibello arrived at Quinnipiac with a splash, making second team Northeast-10. He finished his career in the school's top 10 in hits (151), doubles (32), and runs (112). (Courtesy of Quinnipiac University.)

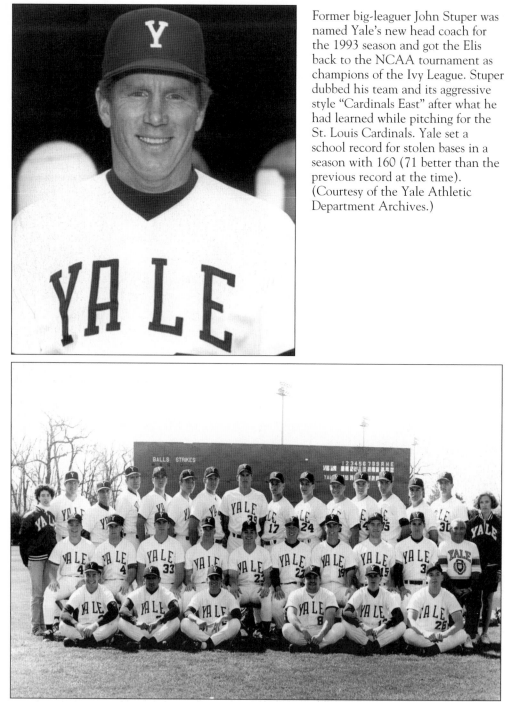

Former big-leaguer John Stuper was named Yale's new head coach for the 1993 season and got the Elis back to the NCAA tournament as champions of the Ivy League. Stuper dubbed his team and its aggressive style "Cardinals East" after what he had learned while pitching for the St. Louis Cardinals. Yale set a school record for stolen bases in a season with 160 (71 better than the previous record at the time). (Courtesy of the Yale Athletic Department Archives.)

The 1993 team set a school record with 33 wins and also produced 10 players that went on to sign professional contracts. That group included hard-throwing lefty Dan Lock (last row, eighth from left), who went to Houston in the second round of the 1994 draft as the 51st overall pick in the country. That made him Yale's highest pick since Ron Darling in 1981. (Photograph by Sabby Frinzi, courtesy of the Yale Sports Publicity Department.)

Dan Thompson was the Ivy League Pitcher of the Year in 1996, but he did just as much damage at the plate as he did on the mound for Yale. Thompson hit .410 with 54 RBIs and went in the 22nd round of the draft to the Milwaukee Brewers as an outfielder. (Courtesy of the Yale Sports Publicity Department.)

Before coming to Quinnipiac, Tim Belcher's biggest moment on the baseball field came when he was struck by a bolt of lightning during an American Legion game. He survived the life-threatening experience and even got an autograph from his big-league namesake, who wrote, "Hit those bolts. Don't catch them." Belcher then made a name for himself with the Braves. He finished his Quinnipiac career with 200 hits, one shy of the school record, and a .361 batting average. In his senior year, 1997, he came to the plate with the bases loaded 12 times and hit five grand slams—a feat that is believed to be an NCAA record. (Courtesy of Quinnipiac University.)

Southern Connecticut State coach Joe Bandiera guided the Owls to the NCAA Division II New England Regional tournament with a 38-17 record in 2001. He retired that season after a 26-year career with a record of 469-426-5. (Courtesy of Southern Connecticut State University Sports Information.)

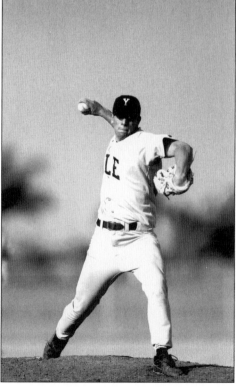

The son of two Yale professors, Jon Steitz was drafted by the Anaheim Angels out of high school but chose to pitch for Yale instead. After posting a 2.66 ERA with 81 strikeouts in 64$^1/_3$ innings as a junior in 2001, Steitz was drafted again, this time in the third round by the Milwaukee Brewers. (Photograph by Wagner Photography, courtesy of the Yale Athletic Department Archives.)

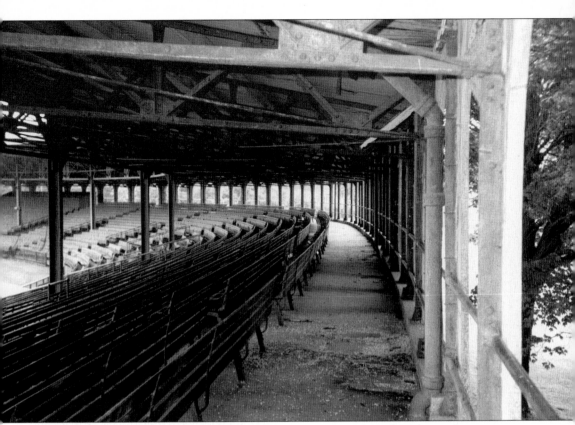

In the spring of 1992, Yale identified the need to renovate its baseball stadium. The university contacted some prominent alumni, including former baseball player Chris Getman and classmate W. Edward Massey. While in the process of raising funds for the renovations, the group learned that, with the addition of the Colorado Rockies and the Florida Marlins at the Major League level in 1993, the Eastern League would be expanding to include two more Minor League teams in 1994. Soon, the project of renovating Yale Field grew to even bigger proportions. (Courtesy of the Rubins.)

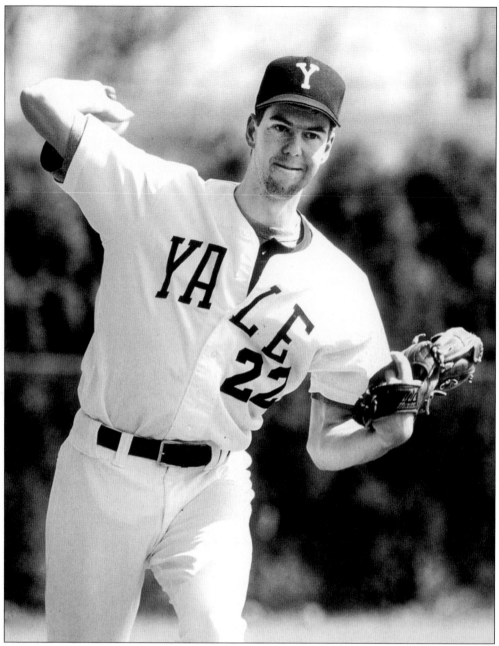
One of the key members of the group that applied for the expansion franchise for New Haven was former Eli hurler Joe Zajac. With his Yale baseball career winding down, Zajac took on the job of expansion coordinator in 1992. (Photograph by Paul Nisely, courtesy of Joe Zajac.)

Eight
THE RAVENS LAND

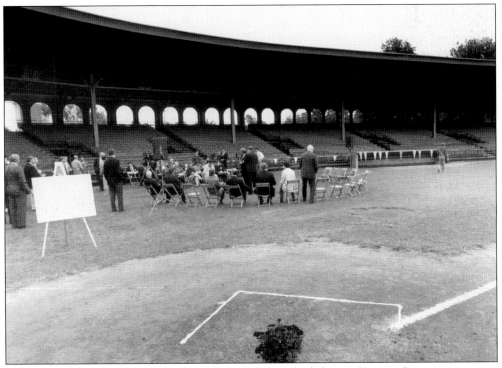

The group behind the renovation of Yale Field applied for an Eastern League expansion franchise in 1992. Soon, New Haven was one of four finalists—along with Portland, Atlantic City, and Nassau County—for the two franchises. On September 30, New Haven made its pitch to the expansion committee with Yale Field as the backdrop. On October 3, New Haven and Portland joined the world of Minor League Baseball. Former Bulldog Joe Zajac became the team's first employee, taking the position of director of operations. (Photograph by Kirby Kennedy/New Haven Register, courtesy of the Yale Athletic Department Archives.)

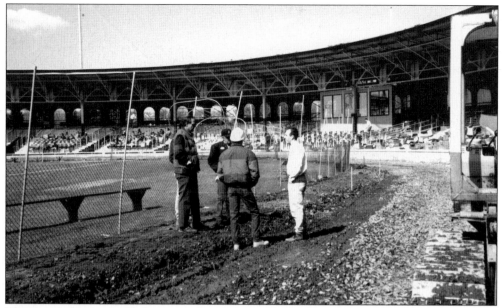

The new team soon added a general manager—Charlie Dowd. Dowd (right) is shown here checking on the progress of the Yale Field renovations, which began in 1993. While the playing field remained in the same location that it had been in for over a century, the seating area was completely replaced. Only the outside wall, with its signature arches, remained untouched. (Courtesy of the New Haven Ravens.)

A "name the team" contest led to the name "Ravens." Before long a large egg hatched at the Connecticut Post Mall, revealing the team's new mascot, Rally. (Courtesy of the New Haven Ravens.)

A crowd of 6,667 packed Yale Field for opening day, April 14, 1994. The Ravens fell to the Reading Phillies 2-1 but rebounded the next night for their first win. They struggled for much of April, going 6-12, but a combined 38-22 mark in May and June helped propel them to an Eastern League playoff berth. The Binghamton Mets brought the Ravens' season to a close in the first round with a 3-0 sweep of their series. (Courtesy of the Rubins.)

Juan Acevedo was a relative unknown when he arrived in New Haven but quickly developed into the ace of the 1994 pitching staff. Between May 15 and July 2, he reeled off nine straight wins. He finished the year atop the Eastern League in wins (17) and ERA (2.37) and was named Eastern League Pitcher of the Year. The following spring, he and teammates Roger Bailey and Jorge Brito became the first players to go from the Ravens to the big leagues, making the Colorado Rockies' roster out of spring training. (Photograph by Storytellers Photography, courtesy of the New Haven Ravens.)

One of the more poignant tales from the Ravens' early years concerns Lou List (right). When he arrived in New Haven in 1994, one of the first things he did was change his name from Paul to Lou in honor of his recently deceased grandfather. It was not long before the popular outfielder was being greeted with a chorus of "Looouuu" every time he came to the plate. List understood his role on the team as a veteran presence—the Ravens were the ninth team he had played for. That, combined with his clutch hitting (a .278 batting average in 1995) and effervescent personality, made him a fan favorite. Soon there was the Lou List Fan Club, complete with its own Web site. List even got his own segment on the Ravens' pregame radio show, *Lou's Views*. Sadly, List's career was cut short by Hodgkin's disease, which claimed his life in the winter of 1997. The team retired his uniform number, seven, in a moving ceremony the following season. (Photograph by Andy Pippa, courtesy of the New Haven Ravens.)

Greg Sparks's contributions to the Ravens' playoff run in 1994 came mainly off the field, where his 10 years of experience helped him become a steadying influence on the younger players. He was also a key part of keeping the clubhouse loose, earning the nickname "Beavis" due to his resemblance to a popular cartoon character at the time. His teammates even arranged to have the scoreboard at Yale Field show a picture of the character during Sparks's at-bats. (Photograph by Andy Pippa, courtesy of the New Haven Ravens.)

Chris Canetti had played at Yale Field while with Quinnipiac College. Looking to stay in the game, he returned as the Ravens' clubhouse manager for the 1994 season. Canetti gradually worked his way through the organization until 1998, when Charlie Dowd left. Canetti, all of 26 years old, was named as the team's new general manager. (Courtesy of Chris Canetti.)

Ravens fans got a taste of Craig Counsell's gritty nature in 1994, well before he became a World Series hero for the Florida Marlins and Arizona Diamondbacks. Counsell suffered a broken nose on July 29 and then tried to make a comeback with a mask over his face a week later. He got a hit in his lone at-bat before returning to the disabled list. (Photograph by Storytellers Photography, courtesy of the New Haven Ravens.)

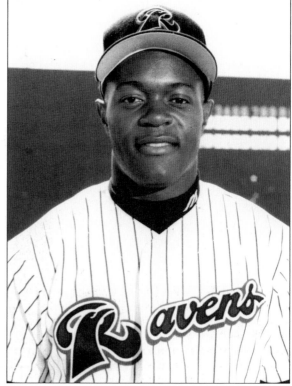

Quinton McCracken was an early fan favorite. "Q" was talented (he was the Rockies' Minor League Player of the Year in 1993 at Central Valley) and bright (he finished a double major in political science and history at Duke in four years). After a slow start at New Haven in 1994, he rebounded to finish with a .278 batting average and 36 steals. He began the next season back at New Haven, but a .357 batting average earned him a promotion to Triple-A after 55 games. He made it to the big leagues later that season. (Photograph by Storytellers Photography, courtesy of the New Haven Ravens.)

One constant throughout the New Haven area's baseball history was Max Patkin (right). Having performed at West Haven Sailor games and West Haven Yankee games decades earlier, Patkin returned to the area to work Ravens games in 1994 and 1995 with his unique brand of baseball comedy. (Photograph by Andy Pippa, courtesy of the New Haven Ravens.)

Hall of Famer Bob Feller (right), who had also appeared at a West Haven Yankees game 20 years earlier, came to Yale Field in 1995 to pitch batting practice and sign autographs before a Ravens game. (Photograph by Storytellers Photography, courtesy of the New Haven Ravens.)

Ravens general manager Charlie Dowd (right) greets some of the former West Haven Sailors on hand for a day in their honor in 1995. The Ravens wore vintage uniforms to celebrate the occasion. Vito DeVito (second from left), a longtime coach at Yale, was also the only Sailor to put a ball in play against Satchel Paige during one memorable game. Paige pitched only three innings. He struck out eight men before DeVito got up and managed to ground out sharply to end the third inning. (Photograph by Storytellers Photography, courtesy of Harry M. Noyes.)

A native of nearby Bridgeport, Angel Echevarria (left) nearly let the "hometown hero" label slip through his fingers, struggling to a .253 average in 58 games in 1994. He returned refocused the following season, setting three goals: hit .300, hit 20 home runs, and drive in 100 runs. He achieved them all and was a key part of the Ravens' run to a second straight playoff appearance in 1995. This one ended with a loss to the Reading Phillies in the championship, three games to two. (Photograph by Andy Pippa, courtesy of the New Haven Ravens.)

Jamey Wright (right) pitched only one game in the regular season for the Ravens in 1995, but the former first-round pick was tabbed for a start in the playoffs. He won the Northern Division clincher against Portland with six shutout innings. Wright was just as dominant when he returned to New Haven to start 1996. He did not give up an earned run until the eighth inning of his fourth start and was 5-1 with a 0.81 ERA when he was promoted to Triple-A Colorado Springs in May. He made it to the big leagues later that year. (Photograph by Storytellers Photography, courtesy of the New Haven Ravens.)

Few players came to New Haven with as much hype as Todd Helton. As the Rockies' first-round draft pick in 1995 and as a former football and baseball star at the University of Tennessee, Helton faced great expectations in 1996—and delivered. His .332 batting average earned him a promotion to Triple-A after just 93 games, and he made his Major League debut the following season. (Photograph by Storytellers Photography, courtesy of the New Haven Ravens.)

117

The opponent sometimes wound up being the attraction at Yale Field. Such was the case in May 1997, when the Yankees sent Dwight Gooden to make a rehab appearance for the Norwich Navigators against the Ravens. A crowd of 6,352 showed up to watch Doc work five innings, allowing three hits and one run. With Gooden out of the game, the Ravens rallied for four runs in the ninth but still came up short, 7-5. (Photograph by Andy Pippa, courtesy of the New Haven Ravens.)

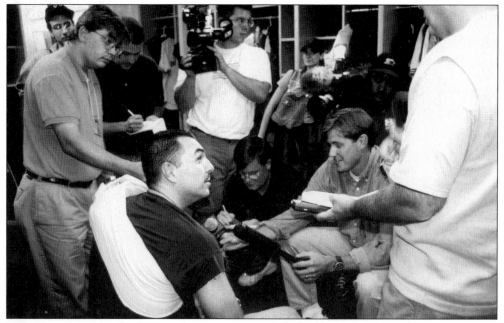

John Franco, another big-league player on injury rehab, had been to Yale Field as a part of the 1981 St. John's team that beat Yale's Ron Darling 1-0 in the NCAA Regionals. Franco returned to New Haven to face the Ravens as a Binghamton Met in September 1999, pitching $1^1/3$ scoreless innings with one strikeout before deeming himself ready to return to the bigs. (Courtesy of the New Haven Ravens.)

The Ravens were touched by tragedy again in 1997. Doug Million, a former first-round pick of the Colorado Rockies, was in Arizona that fall trying to work through the control problems that had led to a disappointing 0-5 record and 9.23 ERA in 40 innings with the Ravens. Million suffered an asthma attack at a restaurant, passing away just before his 22nd birthday. (Courtesy of the New Haven Ravens.)

Outfielder Dave Feuerstein ran through the Yale record book in the mid-1990s, setting the record for most steals in a season in 1994 (41). Feuerstein added 30 in 1993 and 26 in 1995, giving him three of the top six performances in school history. Drafted by the Colorado Rockies in 1995, he began his ascent up the Colorado farm system and, in 1998, landed back at Yale Field as a Raven. He hit .273 in 608 at-bats in New Haven. (Left, photograph by S.R. Smith, courtesy of the Yale Athletic Department Archives; below, photograph by Andy Pippa, courtesy of the New Haven Ravens.)

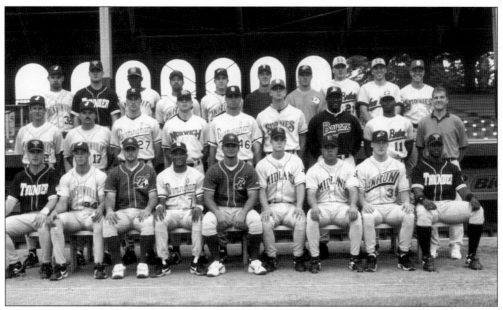

New Haven hosted one of Minor League Baseball's showcase events in 1998, the Double-A All-Star Game. Among the stars on the American League squad were future Oakland Athletics third baseman Eric Chavez (front row, fifth from left), who was then with Huntsville, and future Minnesota Twins outfielder Torii Hunter (second row, second from right), who was then with New Britain. (Photograph by Andy Pippa, courtesy of the New Haven Ravens.)

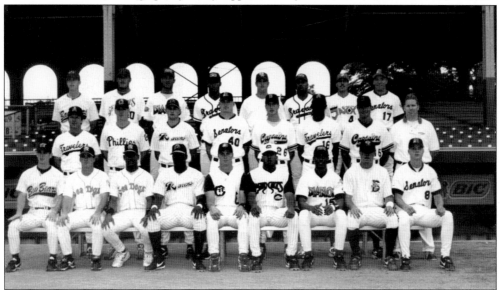

The National League squad featured the two Ravens representatives—pitcher Scott Randall (second row, third from left) and outfielder Wonderful Monds (front row, fourth from left). Monds's first name had been in his family ever since his great-grandfather exclaimed, "Wonderful! Terrific!" upon hearing he had given birth to a son after a long string of daughters. Ravens fans felt similarly excited during the All-Star Game—Monds's two-run home run in the third inning provided the decisive runs in the National League's 2-1 victory over the American League. (Photograph by Andy Pippa, courtesy of the New Haven Ravens.)

A new phenomenon amongst the Ravens fans in section 12 started drawing attention in 1999. In addition to cheering for Ravens second baseman Adonis Harrison, fans in that section began posting pictures of Ricky Ricardo for each strikeout of an opposing batter and chanted Ricardo's "Babalu" each time a Ravens pitcher got to two strikes. Harrison eventually moved on, but the Babalus stayed and became well known to all who passed through Yale Field. (Courtesy of the New Haven Ravens.)

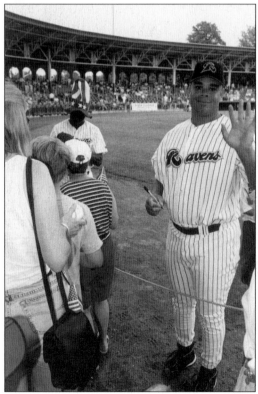

The biggest addition (literally) to the Ravens in 1999 was Juan Thomas, who was 6 feet 4 inches tall. He was listed at 265 pounds and was known as "the Large Human." His booming bat and boisterous personality had an immediate effect. The Ravens were in the basement when he arrived midway through the year, but he sparked a run at a playoff berth with 16 home runs in just 71 games. The Ravens fell short of the playoffs, but the stage was set for 2000, when Thomas returned for a full year and set the team record for home runs (27). The addition of some key players around him made it a special year for the team as well. (Courtesy of the New Haven Ravens.)

The statistics tell the story of just how dominant Greg Wooten (right) was in 2000. The control artist finished the season with more wins (17) than walks (15), pitching 179$^{1}/_{3}$ innings. He led the league in ERA (2.31) and was named Chase Eastern League Pitcher of the Year. More importantly, Wooten's work helped lead the Ravens back to the playoffs for the first time since 1995. (Courtesy of the New Haven Ravens.)

Jermaine Clark was another key component to the Ravens' 2000 playoff run. The scrappy second baseman finished second in the Eastern League in on-base percentage (.421) and proved to be a consistent spark at the top of the lineup. Clark continued his hot hitting in the playoffs, hitting .464 as the Ravens made it past Binghamton 3-1 in the Northern Division championship series and then beat Reading 3-1 for the Eastern League title. Clark was named Eastern League championship series MVP. (Photograph by SID, courtesy of the New Haven Ravens.)

There was no better person to be on the mound for the final out of the Ravens' 2000 Eastern League championship victory than Brian Sweeney. Sweeney had endured more than his fair share of ups and downs throughout the season, including the death of his mother, the birth of a daughter, and trips back-and-forth to Triple-A and to the disabled list. He was moved from the starting rotation into the bullpen midway through the year. With the tying runs on base in the ninth inning of the championship clincher, Sweeney came on to record the final two outs, touching off a wild celebration. (Photograph by Still Life Productions/Milford Photo, courtesy of the New Haven Ravens.)

George H.W. Bush returned to Yale in the spring of 2001 as part of the university's tercentennial celebration. He stopped by Yale Field to address the baseball team at practice. While there, he also talked baseball with some New Haven Ravens staff members, recalling the day 53 years earlier that he met Babe Ruth on that very same field. (Courtesy of Corey Brandt.)

Yale students were responsible for one of the Ravens' most memorable nicknames. A group of them took the last two letters of letters of infielder Alex Eckelman's first name and combined them with the first two letters of his last name to get "Exec" and then "Executive." They then took that to the next level, dubbing him "the CEO." The moniker stuck, and Eckelman eventually had his own column on the team's Web site—"Memo from the CEO"—and replica tee-shirts bearing the nickname and his No. 12. (Photograph by Ron Waite/PhotoSportacular, courtesy of the New Haven Ravens.)

The Ravens' first no-hitter came in dramatic fashion in the first game of a doubleheader on August 11, 2001. Lefty Les Walrond pitched seven innings without allowing a hit to the visiting Portland Sea Dogs, but the Ravens still trailed 2-1 heading into the bottom of the seventh. Portland had scored twice in the third inning on an error and a sacrifice fly. Needing two runs to make Walrond's no-hitter complete, the Ravens offense went to work. Alex Eckelman got things started with a single up the middle, and Jason Bowers followed with a blooper to right. Damon Thames executed a perfect sacrifice to move both runners into scoring position. The Sea Dogs elected to walk Shawn Schumacher, who was pinch-hitting for Walrond, to face Esix Snead. Portland reliever Blaine Neal got two strikes on Snead before he lined a pitch into right field to score both Eckelman and Bowers, touching off a wild celebration amongst the players and the crowd. Walrond finished the game with four walks and six strikeouts. Ironically, after going seven years without a no-hitter, Jimmy Journell pitched another one for the Ravens less than a month after Walrond did. (Photograph by Ron Waite/PhotoSportacular, courtesy of the New Haven Ravens.)

The Green Monster in center field has been a tantalizing target for batters at Yale Field for over 70 years and countless hundreds of professional, college, and high-school games. It was bested once in 2002, by Ravens outfielder Dee Haynes. Only two others have homered over it during Eastern League play, including New Britain outfielder Jose Malave and Ravens outfielder Jayson Bass. (Courtesy of the Rubins.)

In 2002, Stanford-educated first baseman John Gall came up with one of the most popular promotions in Ravens history. He decided that he did not want to drive his Cadillac Eldorado all the way back to his home in California after the season. So, he arranged to give it away to a fan through a year-long contest. In the middle of the fifth inning at every game, the "Gall Mobile" circled the field. It was frequently decorated according to certain themes, such as "Italian Night." Fans were invited to throw softee balls into it through its open windows. Those who got balls in the car were invited back to a game at the end of the season, when the lucky winner was selected. (Photograph by Patty Garguilo, courtesy of the New Haven Ravens.)